Sundancing

Sundancing

HANGING OUT
AND LISTENING IN
AT AMERICA'S
MOST IMPORTANT
FILM FESTIVAL

JOHN ANDERSON

SPIKE
AN AVON BOOK

AVON BOOKS, INC.
1350 Avenue of the Americas
New York, New York 10019

Copyright © 2000 by David Morgan
Interior design by Rhea Braunstein
Published by arrangement with the editor
ISBN: 0-380-80480-8
www.spikebooks.com

Library of Congress Cataloging in Publication Data:

Anderson, John, 1955 March 10–
 Sundancing : hanging out and listening in at America's most important film festival / John Anderson.
 p. cm.
 Includes bibliographical references and index.
 1. Sundance Film Festival. 2. Motion pictures—Interviews. I. Title.
PN1993.4.A55 2000
791.43'75—dc21 99-039934

First Spike Printing: January 2000

SPIKE TRADEMARK REG. U.S. PAT. OFF. AND IN OTHER COUNTRIES, MARCA REGISTRADA, HECHO EN U.S.A.

Printed in the U.S.A.

OPM 10 9 8 7 6 5 4 3 2 1

CONTENTS

ACKNOWLEDGMENTS

For their invaluable help in the creation of this book, I would like to thank, first, the three talented filmmakers who form its "spine": Doug Block, who shared his veteran's wisdom about the Sundance experience and the noble resignation of that happily crazy species, the documentarian; Gavin O'Connor, whose awe and energy were so refreshing and captured so much of what the festival means to young directors; and David Riker, whose very personal brand of intellectual and social commitment often gets lost in the fevered race for Hollywood.

To Jennifer Stott of Fine Line Features and its president, Mark Ordesky, both of whom contributed a relatively enormous amount of time mid-festival. To Bingham Ray and Amy Taubin for their enlightening and caustic insights into the Sundance mythos. To the filmmakers included here—particularly Errol Morris, Mike Figgis and Eric Mendelsohn—for sharing their bemusement about the whole thing. And to the various publicists, such as Laura Kim, Liz Berger and Mark

Pogachefsky, who often seem to be running the whole show and probably do.

Thanks also to Geoff Gilmore, the longtime programming director of Sundance, who may not be an integral part of this book per se, but who over the years has been a font of information about the festival, as well as a tireless promoter of its mission and (most important) its filmmakers.

JOHN ANDERSON
Summer 1999

CAST

(in alphabetical order)

Robert Altman	Director, *Cookie's Fortune*
Gregg Araki	Director, *Splendor*
Steve Barnett	Denise Di Novi Pictures
Michael Barker	Copresident, Sony Pictures Classics
Sgt. Bruce Bennion	Park City Police Department
Liz Berger	Publicist, mPRm Public Relations
Jami Bernard	Film critic, *New York Daily News*
Tom Bernard	Copresident, Sony Pictures Classics
John Bernstein	Photographer/journalist
Doug Block	Director, *Home Page*
Kenneth Branagh	Director
Matthew Braun	Volunteer
Tony Bui	Director, *Three Seasons*
Edward Burns	Director
Steve Buscemi	Actor, director

ix

Rick Caine	Video journalist, Associated Press
T. Patrick Carroll	Actor
Annabel Chong	Actress, *Sex: The Annabel Chong Story*
David D'Arcy	NPR Correspondent
Paola di Florio	Director, *Speaking in Strings*
Jeff Dowd	Los Angeles producer's rep
Rod Dreher	Film critic, *New York Post*
Sarah Eaton	Publicist, October Films
Atom Egoyan	Director
Eric	Security guard
Edie Falco	Actress, *Judy Berlin*
Sgt. Sherm Farnsworth	Park City Police Department
Mike Figgis	Director, *The Loss of Sexual Innocence*
Christine Garcia	Owner, Christine's Bake Shop
Susan George	*Texas Daybreak*
Geoffrey Gilmore	Program director, Sundance Film Festival
Bob Giovannelli	Volunteer
Adrienne Gruben	Producer, *Treasure Island*
Marvin Halpern	Festivalgoer
Aaron Harnick	Actor *Judy Berlin*
Robert Hawk	Sundance Film Festival advisory selection committee
Rick Hemner	Journalist
Travis Haywood	Driver and travel coordinator
Melissa Kaffey	Park City facilities and special events manager

Ken Kesey	Author
Laura Kim	Publicist, mPRm Public Relations
Diane Lane	Actress, *A Walk on the Moon*
Cory Larson	*Texas Daybreak*
Michelle LeBrun	Director, *Death: A Love Story*
Gough Lewis	Director, *Sex: The Annabel Chong Story*
Jeff Lipsky	Head of acquisitions, Samuel Goldwyn Co.
Lisa Loeb	Singer
Derek Malcolm	Film critic, *The Guardian*
Heather Matarazzo	Actress
Debbie Melnyk	Journalist, Associated Press Television
Eric Mendelsohn	Director, *Judy Berlin*
Helen Mirren	Actress, *The Passion of Ayn Rand*
Elvis Mitchell	Film critic, juror
Michael J. Moore	Director, *The Legacy*
Errol Morris	Filmmaker, *Mr. Death*
Howie Moshkovitz	Film critic
John Oblad	Festival shuttle driver
Dennis O'Connor	Senior Vice President, Trimark Pictures
Gavin O'Connor	Director, *Tumbleweeds*
Mark Ordesky	President, Fine Line Features
Tom Ortenberg	Copresident, Lions Gate Films
Reed Paget	Director, *Amerikan Passport*
Alison Palumbo	Festivalgoer

Cynthia Palumbo	Festivalgoer
Robert Panzarella	Physician-filmmaker, *Texas Daybreak*
Frank Perry	Director
David Pierce	*Texas Daybreak*
Bill Plympton	Animator
Nik Powell	Juror
Bingham Ray	Copresident, October Films
Robert Redford	Founder, Sundance Institute
David Riker	Director, *La Ciudad* (*The City*)
Esther Robinson	Producer, *Home Page*
Rachel Rosen	Programmer, San Francisco Film Festival
Ann Russell	Volunteer
Sgt. Rick Ryan	Park City Police Department
Susan Saks	Festivalgoer
Paul Schrader	Director
Liev Schreiber	Actor
Lisa Schwartzbaum	Film critic, *Entertainment Weekly*
Chloë Sevigny	Actress
Ally Sheedy	Actress
Duncan Sheik	Singer
Steven Soderbergh	Director
Janet Sprissler	Volunteer
Jennifer Stott	Executive director, publicity/promotions, Fine Line Features
Bob Tarpy	Festivalgoer
Marilyn Tarpy	Festivalgoer
Amy Taubin	Film critic, *The Village Voice*

Claire Terraciano	Administrative director, Film Forum
Mark Urman	Copresident, Lions Gate Releasing
Rebecca Yeldham	Festival programmer

Sundancing

Introduction

"Sundance is my favorite festival in the world."
> —Bill Plympton, animator, at Sundance 1997

"It's chaos."
> —Tom Bernard, Co-President of
> Sony Pictures Classics, at Sundance 1998

"Obviously, I think Park City is the greatest place in the United States!"
> —Steven Soderbergh, director, at Sundance 1992

"This part of the country brings out the Gary Gilmore in me. You know, 'Let's go down to the 7-Eleven and shoot somebody.' "
> —Paul Schrader, director, at Sundance 1992

"It has gotten to be a monster."
> —Robert Redford, Sundance 1995, 1996, 1997

Sundance. It represents the hopes and dreams of any young filmmaker who ever pressed him- or herself up against the golden gates of Hollywood. The most important single film event in the United States—and among the three or four most prestigious in the world—it can be a godsend for some, a heartbreak for others, and is always a barometer of a film-crazy culture's national cinema.

The Sundance Film Festival has been described as America's Cannes—except that instead of being held in May, beside the sun-drenched Mediterranean, in the balmy south of France, it takes place in snow, 8,000 feet above sea level, in a state (Utah) whose political landscape is more than a little antithetical to the (pseudo?) progressive sentiments of an independent film festival.

But Sundance has survived these perceived handicaps, and thrived, thanks to the cachet of its guiding light, Robert Redford, to the efforts of its administrators, and—most of all—to the rising fortunes of a film subculture and industry whose very success has become inseparable from that of Sundance itself.

If Sundance were something else—a painting, a building, a play—it would be *Guernica*, the Eiffel Tower, *An Enemy of the People*, a splitter of opinion, a causer of psychic riots, a monkey wrench in the Zeitgeist. At the same time, the analogies should really be American, because that—above all—is what Sundance *is*.

"Founded by Robert Redford" is the way a lot of stories on the festival begin, and they're wrong. Redford

didn't found the festival now known as Sundance; the United States Film Festival (a title retained until 1989, four years after Redford's Sundance Institute took over its operations) had existed since 1978, begun by the Utah Film Commission as a way of luring noted film-makers to the Beehive State. Retrospectives were the main draw; a handful of regional premieres were shown. The atmosphere was low-key to the point of vacation; people skied the local Wasatch Mountains as often as they screened movies.

Ah, but that was long ago, and far away. In 1998, during the 20th anniversary festival, more than 120 films were shown. More than 12,000 people swarmed into tiny Park City, and so many cell phones were in operation that the relay system simply overloaded for most of the festival's ten-day duration.

All this would seem to indicate that Sundance is a roaring success. Certainly it's a diversified institution: an annual screenwriters' lab, a directors' workshop, theatrical offshoots, TV's Sundance Channel, a new the-ater chain, a clothing catalog. The festival itself draws a seemingly endless stream of Hollywood "types" look-ing for talent, and generates the kind of attention and energy for which any film festival director would give his right Rolodex.

But ever since Steven Soderbergh's *sex, lies and video-tape* forever changed the face of both Sundance and independent film back in 1989—by proving the market potential of independent films—the debate has raged over whether Sundance has fulfilled whatever promise

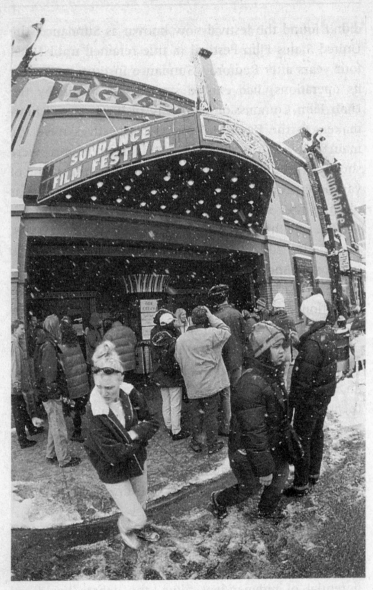

From ice to fire; film buffs pass from snowstorms into the heated media atmosphere of the festival's fare on-screen.

it had made to filmmakers and filmgoers. Has its high-profile, gold-at-the-end-of-the-rainbow siren song forever warped the making of American movies? En route to helping make domestic independent cinema the weighty thing it is today, has Sundance merely reflected the changing face of the indie scene, or has it been the catalyst? While paving the way to El Dorado for some young (even visionary) filmmakers, has it left far more of their compatriots littering the roadside?

Sundance has certainly changed since 1989. "After *sex, lies and videotape* it was never the same," Robert Hawk, a longtime member of the festival's advisory selection committee, told the *Seattle Times* in 1998. "It was just a phenomenon. Up until then, it had this low-key Redford aura and was more manageable. Afterward, it really became more of a zoo"—meaning crowds, anxiety, and the ineffable feeling that wherever you are, you're missing something bigger, better, and buzzier someplace down the street.

How the zoo ambience affected the movies is another story. Sundance the entity would argue that the festival is merely a mirror for the ever-expanding world of independent films. As longtime program director Geoff Gilmore said in 1993, "One of the things people always misinterpret is that when the industry becomes enormously interested in you, you change the nature of your work to cater to it. I really don't believe we have, and if you look at the programming we've done it indicates that."

This belies, of course, the influential-bordering-on-

insidious nature of Sundance's success. One thinks of Sundance and all those young, would-be Tarantinos as one thinks of inner-city kids and the NBA. "The odd thing about Sundance is, I find there's a kind of casualness here, but it's not casual at all," said director Atom Egoyan, while serving as a juror in the mid-'90s. "I thought, when I was invited to be on the jury, that the films were going to be smaller—sixteen millimeter, very marginal efforts. But they're actually very glossy, a lot are thirty-five millimeter, and these people are just pouring so much of their savings and everything else into these films. The stakes are pretty high."

And for what? The chance to make it big—or, more often, the opportunity to show Hollywood what they can do with a very limited budget and limited resources, so that some studio will give them the budget and resources necessary to make the film they've (often) already made.

◊ ◊ ◊

Independence has certainly been a calling card of Sundance. So has another very American trait: defiance.

Consider, for one thing, the festival's decision to remain all these years in Park City—a town woefully ill-equipped in almost every way for an event this size, and one annually baffled by the influx of harried New Yorkers and Los Angelenos. (When screenwriter-director Neal Jimenez, whose *The Waterdance* won the Audience Award and Waldo Salt Screenwriting Award in

1992, stayed at the Olympia Hotel, there was a note behind the registration desk posted for the benefit of the receptionist: "Sounds like Hemenez, actual spelling Jimenez, is in 208.")

Consider, for another, the contortions the festival goes through to mount a roster of politically correct films. "One of the more difficult things to do with the festival this year is to typify it," Gilmore said—quite typically—in 1992. "And that's a goal. We try very hard not to have fifteen very slick melodramas made by white males. It's intentional for us to show a range of different kinds of independent cinema."

But unless diversity equals excellence—and no Sundance festival yet has proved that prickly point—why bother?

"There are political reasons films don't get chosen," said Jeff Lipsky, a cofounder of October Films and now with the Samuel Goldwyn Co. "But there are thematic reasons [why] they don't get chosen, which should never enter into the equation on any film. They want balance. Why? Discovery, quality, that's what it should be all about. If there are thirty-seven films about hermaphrodites that are the best films that year, those are the films they *should* select."

Naturally, Sundance is too high profile not to want to cover every demographic base, to maintain its position as a progressive event that recognizes the right of every American to get her or his movie on-screen— even as its selection committee has leaned more and more toward movies featuring recognizable names:

Independent voices, clockwise from top left: Steven Soderbergh's *sex, lies and videotape* (1989), one of the first true mainstream indie successes out of Sundance; the powerful documentary *Hoop Dreams* (1994); *The Opposite of Sex* (1998), which helped reinvent child star Christina Ricci; and Todd Solondz's *Welcome to the Dollhouse* (1996), featuring Heather Matarazzo.

well-known directors and actors, actors-turned-directors, or producers with agendas.

And this has become the real paradox of Sundance, art be damned: all through its history, it's been the small, no-name, no-budget film that's been birthed by the festival and made money, while the higher-profile movie looking for art-house prestige has tanked as soon as it hit the outside world. Sundance may be easy pickings for Hollywood agents looking for cheap new talent, but its imprimatur doesn't carry much weight with the general public.

But it is unique. For ten days each January, Park City is a place like nowhere else—or like everywhere else. Its audiences have given standing ovations to provocative environmental documentaries like *Earth and the American Dream*, and then done the same for a sentimental "heartwarmer" like *Care of the Spitfire Grill*. In fact, when an audience rose to its feet following a 1996 screening of *Spitfire*, it clinched the happy fate of a film that had gone unsold for months, eventually selling for the princely and very un-Sundance-like sum of $10 million.

Without even giving them awards, the festival has provided the springboard for such disparate filmmakers as Nora Ephron (*This Is My Life*, opening-night film, 1992) and Quentin Tarantino (*Reservoir Dogs*, Dramatic Competition, same year). Its list of honorees include Soderbergh (whose *sex, lies,* contrary to popular misconception, won only the Audience Award in 1989), the Coen brothers, Todd Haynes, Victor Nunez (*A Flash of*

Green), and Todd Solondz (*Welcome to the Dollhouse*). Among the movies "discovered" at Sundance? *Like Water for Chocolate, Crumb, The Brothers McMullen, Clerks, Fresh, Go Fish, Slacker, Poison, House Party* and *Paris Is Burning*.

In other words, American independent film in the '90s is synonymous with Sundance.

◊ ◊ ◊

There are a few things that the reader needs to know about this festival, either politically, programatically, or geographically—and about this book, with which the Sundance Institute and festival declined to be involved. Their primary reason, according to institute director Ken Brecher, was because Robert Redford feels that the festival is an ongoing, ever-evolving entity, and a book would somehow make it finite. Because of the noninvolvement of Official Sundance, other perhaps key players chose not to be interviewed as well (notably Harvey Weinstein of Miramax, whose company's fortunes have been intertwined with the festival's at least since 1989 and *sex, lies and videotape*).

This book is not a conventional history but rather an attempt to create a kind of snapshot, a festival frozen (aptly enough!) in time, through the words of its participants.

Like a grapefruit, the Sundance Film Festival comes in sections. The World Cinema, Frontier, Midnight, American Spectrum and Premiere sections are noncompetitive. The films in the Dramatic and Documentary

Competitions are eligible for their respective Grand Jury Prizes for best film, for Cinematography Awards sponsored by Eastman Kodak, for Directing Awards sponsored by the Directors' Guild of America, and for the Freedom of Expression Award sponsored by the Playboy Foundation. A Waldo Salt Screenwriting Award is also given out annually, and an Audience Award for both dramatic and documentary film are voted by the public. Two Filmmakers Trophies are voted for by other directors at the festival. There is also an award for Best Short Film, voted by a short-film jury. In all, about 32 feature films were scheduled to screen in competition in 1999; many other features, shorts, and development money–attracting teasers play on the sidelines, some in minifestivals piggybacking onto Sundance (like Slamdance, Lapdance, No Dance, or even One Dance, a one-film "festival" organized by Ralph Waxman to promote his film *Trapped*), hoping the *frisson* of art and commerce will bring them a little heat during these last weeks of January.

Public screenings at the festival are usually introduced by the director, who conducts a question-and-answer session after the film. These Q&As are wildly unpredictable and uneven, but can occasionally be very revealing about both audience and filmmaker. At the 1999 festival, Gough Lewis, director of the controversial *Sex: The Annabel Chong Story,* was asked whether or not Ms. Chong (a porn star and onetime recordholder for the greatest number of acts of intercourse performed in a ten-hour period) had a financial stake in his docu-

mentary. He said she did—thereby altering the perception of the film among the entire audience. Conversely, some directors have had their fortune made at Q&As; both Robert Rodriguez in 1993 and Edward Burns in 1995 greatly enhanced the perception of themselves and their films by being absolutely charming during post-screening interrogations.

The geographic points are as follows: The theaters used by the Sundance Film Festival are the Eccles, a 1,300-seat state-of-the-art auditorium first used in 1998 and attached to Park City High School; the Library, a less-than-state-of-the-art assembly hall (also part of the Park City educational system); the Holiday Cinemas I, II, and III, affectionately referred to as the "Sciatica Triplex"; and the Egyptian, an Art Deco antique situated toward the top of Park City's 45-degree-angled Main Street, which was recently restored and used by the festival in 1999 for premieres and foreign films. Press screenings are held not just at the Eccles, but at the Yarrow Hotel as well, where conference rooms are divided into screening rooms by partitions, through which one can, if bored, sometimes listen to another movie entirely.

One of the problematic things about the proximity of these facilities to each other is that they don't have any: no one theater is within easy walking distance from another, so either the shuttle system (which is good) or private cars (Bad! Bad!) have to be used. This creates problems when sceenings don't start on time, which is often; the festivalgoer needs to calculate travel

time (and the likelihood of the *next* screening starting on time) when deciding whether to bail out of one movie early in order to catch another.

"Sundance" can refer not only to the festival, but also to the Institute or to the ski center/residential area outside of Park City, which is owned by Redford and has its own screening facility. There—as at Salt Lake City's Trolley Square Theater and the Peery's Egyptian in Ogden, Utah—select films are also shown during the festival.

Park City itself? It's situated about 35 minutes from Salt Lake City and, during ten days in January, several light years from anything resembling the real world.

The Veterans

"*A Brief History of Time* won the documentary competition the year it was here, but I was long gone. That was my shortest visit to Sundance. I flew in, rented a car in Salt Lake City, I drove up here, and I just decided I just could not go through with it. And I got back in the car, drove back to Salt Lake City, and headed back to Boston.

"I couldn't face it. I've decided never to go to these film festivals alone. It's probably just raw animal fear."

—Errol Morris, filmmaker

"[Sundance is] certainly kind of a crucial institution in the rise of the indies. Or let's put it this way: a crucial institution in the *institutionalization* of the indies.

—Amy Taubin, film critic, *The Village Voice*

Tom Bernard, who runs Sony Pictures Classics along with Marcy Bloom and Michael Barker: Back when I started with New Line in 1977, there were these guys,

Laurie Smith and Sterling van Wagenen—he produced *Trip to Bountiful* and he was also Redford's brother-in-law. He and Laurie Smith started this festival called the U.S. Film Festival. It was in Salt Lake and the whole criterion for the festival was to find American independent movies.

And there was not a lot to find back then.

But it was the beginning of the Sundance Film Festival. They had the Utah Film Commission's backing because Laurie worked in the location department of the film commission—they became involved because Laurie worked there. He said, "Hey, you guys, we can make this something that will focus on Utah." You know, there were very few small independent festivals back then. Now every city's got a festival; it's become a business.

But this one was different. They ran movies like *Between Time and Timbuktu*. Remember that Kurt Vonnegut PBS movie? New Line had a lot of those movies in its catalog back then; Bob Shaye was probably the front-runner in American independent film. He had everything from *Pink Flamingos* to Norman Mailer. But that's how it started.

In the beginning everyone got to stay for free. If you were one of the chosen few, they flew you out and—you know those Pinnacle condos? They gave away like seven of those four-story condos and basically let everyone stay there. It became like an *Animal House* dorm.

So you had all these wild people who'd watch mov-

ies at night and ski all day, party with all the filmmakers all night long, and it was a real spontaneous-combustion kind of place for filmmaking. Because back then the unions wouldn't let any of their technicians work on independent films. That was one of the reasons it was so hard—either the stuff was tough to watch, it was just out of focus, or you had the consummate filmmaker who did everything.

What happened was, movies came out of this sort of mixture of people; that's how the Sundance labs came to be later. You had cameramen, lighting guys, editors who wanted to find something different than the same old Hollywood shit they'd been working on.

They'd show up out there, meet some guy who was an independent filmmaker who would say, "Oh, yeah, you wanna work on this?" "Yeah—I can do it under an assumed name" or "I'll go to a right-to-work state and low-key it." All of a sudden you started getting these union-trained technicians working on independent films.

I remember on *Drugstore Cowboy*, Gus Van Sant's cinematographer just showed up there looking for work. That's what was great about the festival: there was a purity about it. It wasn't about awards; it was about people looking for what was new in filmmaking. And it became popular as more and more of the union technicians began working on the films, which became more viable in the Hollywood arena.

* * *

Part of what changed things was the so-called East Coast Contract, in which the unions made a deal in the early '80s allowing union technicians to work on low-budget films without being thrown out of the union. It changed the face of independent film—which was about the time that Sundance got the festival.

Michael Barker, Sony Pictures Classics: There still weren't a lot of movies you wanted to pick up. It was a place you wanted to check out; there were new films going on. New directors came—John Sayles had some stuff in—but they struggled to fill a slate.

They had premieres where they'd bring some big name in, linking the studio and independent worlds. But a lot of people with the hottest films in the festival still didn't get distribution.

I think awards are where they started signaling filmmakers that they could win the lottery.

Jeff Lipsky, cofounder of October Films and head of acquisitions for Samuel Goldwyn Co.: There are things wrong with Sundance; there are things right with Sundance. When Sundance first got the festival, they called me to get *Stranger Than Paradise* and I turned them down. I don't remember who the artistic director was at the time—whoever it was that was on the phone with me daily trying to convince me to enter it—but he virtually said to me, "Look—if it goes in, I can almost assure you it's going to win." I said, "Fine, OK, I'll enter it." It lost.

And I realized what had occurred, even then: I had

STRANGER THAN PARADISE
A NEW AMERICAN FILM

Jim Jarmusch's *Stranger Than Paradise* (1984)

fallen prey. Here you had a first feature by an unknown New York filmmaker named Jim Jarmusch, and you're asking him to put his faith in you—as the distributor, as a friend, as a confidant—and make him think, "He'll only do what's right for the film," and you enter it into this competitive environment of first-time filmmakers, and it *loses*. And I realized it's all wrong.

Here's a man, Robert Redford, who for decades has—not rejected exactly, but eschewed the whole competitive notion of the Academy Awards, and now asks first- or second-time filmmakers, who may have stolen, scrimped, saved, borrowed their way into a nominal production budget, to go to Park City and get thrown into competition *with each other*, this barbaric,

Roman-gladiator competition where one person wins—now there are many more prizes—but where one person wins and everybody else becomes a de facto loser.

YOU ARE A LOSER.

And in the press the next day they don't list the losers; they list the winners. So not only are you a loser, you're damaged goods. Suddenly distributors aren't interested and critics who haven't seen the film aren't interested and feature writers aren't interested and foreign-sales reps aren't interested and agents aren't interested and accountants aren't interested and attorneys aren't interested and financiers of your second film aren't interested.

I wrote a letter to Redford that said, "I was wrong. I fell prey to this whole circus and vulgar environment, the kind you yourself have eschewed, and I think it should become a noncompetitive festival." And he wrote a very polite letter back saying, "It would be considered at our next board meeting," which it was or was not. But it's obviously become much *more* competitive over the years.

Steve Buscemi

Steve Buscemi, actor/director: The first two Sundance films I was in, *In the Soup* and *Reservoir Dogs*, were there the same year. After that I was there for a film called *Twenty Bucks* and for *Living in Oblivion*. I don't remember there having been this frenzy around the films. The first year, you could get into screenings and it really wasn't that much of a problem. But then, when there

was a buzz about a screening, there was a lot more hype and more press, a lot more agents. It was harder to get into restaurants, harder to get a dinner—*that* became a whole power struggle, which is really, really odd. Getting into the right place. It just seemed a lot more under a magnifying glass.

I didn't have any expectations when I went the first time. *In the Soup* was the film I was closer to, 'cause I had more of a leading role and I'd worked more closely with director Alex Rockwell and was involved in seeing almost every rough cut. Alex had given me the most responsibility I had ever had for a part. So I just had more invested emotionally in *In the Soup*.

Reservoir Dogs was just a lot of fun to make, but I don't think anybody really knew what it was going to become. The Sundance people talked about it, but it seemed that it might not catch on because people found it too disturbing. We had high hopes for *In the Soup*, after it won the Grand Jury Prize. But going in, I was probably too close to the film to have any expectations.

I remember the first night of its screening sitting in the audience with my wife, feeling sort of depleted, you know, "Well, here we are. . . ." 'Cause at that point I wasn't really sure what we had. And seeing it there with that audience was like seeing it again for the first time; the film seemed to come alive in front of that audience. Seeing how charmed they were by stuff I was no longer charmed by, it was nice to see it through fresh eyes again. So that was a really memorable night. And then with it winning the award and Seymour [Cas-

sel] getting the first acting award they'd given, it was really special.

Did the festival do it any good? I think whoever was responsible for taking advantage of that, didn't. There should have been more mileage out of winning an award at Sundance. But I know there have been other winners at Sundance that haven't gotten great distribution. Which is odd, because it's such a coveted festival now. I have heard, I haven't seen the list, but I have heard that all the films that got in this year already have a distributor.[1]

Lipsky: What's happening, I find, is that filmmakers, especially young first-time filmmakers, now create production schedules and delivery times *for* the Sundance Film Festival. Nobody goes into production in January, because the film would be finished in the summer or early fall and they can't afford to sit on it until Sundance, so what's the point? It becomes a form of artistic inhibition that I haven't really been able to put my finger on—whether that's a good thing or a bad thing or just an absurd thing. Just an anecdotal aberration in our business.

Buscemi: With *Trees Lounge* [his 1996 directorial debut] I suppose I really could have busted my ass to get it finished in time to submit it, but I didn't want to put that pressure on myself.

[1]Actually, while many of the noncompetitive features being premiered had already been sold going into Sundance, only a handful of competing fiction and documentary films had distributors prior to the festival.

Lipsky: In the American Spectrum last year, and the competition, it seemed that at least eighty percent of all the entries had a star name, a star director, a star producer, or a star distributor—and I only list Miramax as a star distributor. I think film festivals should be discovery festivals. I think film festivals ultimately should not be platforms to launch movies. I think film festivals should be places where movies that might never get distribution are discovered by the media, and films that might be so revolutionary or so unique or so niche-driven or so visionary that after all the praise and awards they *still* wouldn't find a way to get distribution, but maybe the filmmaker might find a way to get *another* film made. Not that these films *shouldn't* find distribution, but maybe because it's better than we deserve.

Buscemi: Sundance does provide a glimmer of hope—like maybe other people will be interested. It seems like even films that have distribution, their distributors think it's important to be there because it's so hard these days to launch a film.

It Doesn't Necessarily Represent the Real World

Michael Barker: For us, the most important aspect of Sundance is launching our films. It's really the only place other than the Cannes Film Festival—in some ways it's better—where you have this number of critics in one spot at one time. Last year, one of the reasons *The Opposite of Sex* started off with a bang was because

all the major critics who were at Sundance were at one screening: Janet Maslin, David Denby, David Ansen, Kenny Turan. You know, it becomes very important in how you launch a film, and when those critics and other journalists see the film and then have easy access—even in passing on the street—to the people involved in the film, you get a lot of work done, a lot of positioning done. It really helps those films.

The problem is, if you go to Sundance looking for films to buy, you have to be aware that the Sundance experience isn't like the rest of the country. In other words, when you say, "I want to buy that film; it's going to really work," you can't base it on the audience response here because it doesn't reflect the general moviegoing public.

Bernard: Lots of Mormons in the audience!

Barker: I mean, I know one of the reasons someone stepped up to the plate for a big number on that *Spitfire Grill* movie was that it got this huge standing ovation. It was unbelievable. The thing is that it's important to realize that aspect of it, that it doesn't necessarily represent the real world. Look at *Next Stop, Wonderland* or that film with Parker Posey where she was like Jackie Kennedy [*The House of Yes*]. The response at Sundance was so through-the-roof you would have thought these were going to be some of the most successful independent films of the decade.

Bernard: When films started being bought for huge cash, it became a place where directors thought they could go and make their fortune. I think one of the turning points was when the guys who were PAs and grips on the films couldn't get *into* the films. That's when it turned. It became a commercial festival.

It's always a festival of virgins, always first-time filmmakers—the majority, anyway—who go there. They're not aware of the process, what's a good way to market a movie. They're only aware of the hype and stories that have been written about Sundance, which creates this bubble, makes it the most important place in the world if you're there.

And so they come in plotting and planning that they're going to show up, get a million dollars, and go to Hollywood—rather than, "I have something to say, I have this important movie, there are a lot of people who have the same thoughts I do and I can come and meet with them and talk about the purity of our films and the noncommerciality of it and getting our message across without having to sell out." Where now, it's like, "Let's go there and sell out with a vengeance."

I think the classic example is *Hurricane* [Sundance 1997], where they met with everybody in the industry, came by, wanted to know how much money you had, basically said everything short of "When the movie's over, line up and take a number. We want a million dollars." They got their million dollars and the movie didn't come out for a year and a half. They changed the name [to *Hurricane Streets*], and anything that was

hot coming out of that festival fell by the wayside, and the movie didn't get what it deserved because of the greed factor.

Now it's, "What can you do for me?" There were millions of them. The *Pi* guys and others last year. They've come in this year, too. This year the new thing is they all have the L.A. talent agent selling their movie: William Morris, ICM. They all have an agent who's going to conduct an auction.

My reaction is it's a real disservice to the filmmakers. Because the festival is not designed for commerce. Yet it's the most commercial festival outside of Cannes. You can go to Cannes and still deal with art, great cinema, people who have ideas they want to exchange, because there's a section set aside at Cannes to do business. There's a market. Organized. People have places where you can find them; there are screenings just for business purposes. Sundance is like an ostrich with its head in the sand, refusing to recognize the commerce that goes on in the festival and *organize* it. If you're an independent filmmaker, it's like guerrilla salesmanship. There's no one place people go to do business; the cell phones don't work, and you're running from hotel to hotel.

If you're at the right place at the right time, you might be able to make your sale, but it's total chaos. I think a lot of filmmakers aren't in a position to cash in and find out what's best for their film—which is sitting down with all the people who might be interested in their film, the marketing people, the sales people, hav-

ing the publicist be able to help discuss what's going on with the critics, to be able to sit down in a place with a phone and a fax machine, an office you can go to. If you couldn't make the screening—'cause there's four screenings all over the state—there should be a place you could go and actually see the movie without upsetting the festival's ticket sales. Anyway, I think that's a real problem. The commerce hasn't been put in a box so you could get on with the business of seeing movies.

They're a market and refuse to admit it. The majority of the filmmakers go there looking for dollars. And what I've found there, unlike any other festival, is that the filmmakers are very competitive with each other.

Liev Schreiber, actor, *A Walk on the Moon*: My movie *The Day Trippers* was at Slamdance, but I was here with *Walking and Talking* and for *Denise Calls Up* and *Big Night*, and I like it. I like the fact that everybody's into film—they're all speaking and buzzing about films, people are really hungry and enthusiastic, the audiences are very keyed up. If they like it, you know. If they *don't* like it you know it. I like that kind of audience. They're awake, they're aware, they're informed, and they're buzzing.

People say this kind of thing: "Yeah, it's become a place where people are selling movies." But any good film festival is going to become that, 'cause where else are you going to find good filmmakers whom people

haven't heard of? It's the nature of the beast. It's going to happen.

I think this place is nothing compared to Cannes; this is like a corner market compared to a mall. At least this place has a standard. Cannes has standards, too, but seventy-five percent of the pictures in Cannes are like soft porn stuff. They've got the Palme d'Or— "Oooh, the Palme d'Or"— sure. But you ever go look at the industry section? It's a huge market. Every film festival is—every film festival that gets any press. And then people go and compete for films. But it's cyclical. And it's one of the hard things, the struggle between art and commerce.

Mark Urman, copresident, Lions Gate Films: A lot of the films are just too fragile for this world. There are also only a handful of distributors who are interested in these movies, and they can only release a certain number of films a year, and some films inevitably will unjustly fall by the wayside.

The Bubble of the Festival

Bernard: You might say all the mayhem is furthering the Sundance catalog. But there can be just as much press and acquisition done in an orderly fashion, as in the chaos they have there.

A few years ago, we had a party with Los Lobos, when we had *Mi Vida Loca* there, and they had a couple of local cops working the door at this massive event,

and all the wrong people were getting arrested and thrown out on their butts, because the festival took charge of the security. It was really run in a grass-roots manner back then. But even then, it was bigger than that. I remember an agent saying he'd buy me a coat, a sweater, anything I wanted, if I could get him a meeting with Sally Potter. She was there with *Orlando*, and *Orlando* was a hot movie in the bubble of the festival; she was one of the biggest things there. And this agent was like, "I gotta meet Sally Potter before anyone else."

We'd bought *Orlando* in Toronto. And we bought *Welcome to the Dollhouse* (which won Sundance in 1996) at Toronto, too. But Toronto's an organized place. They devote a lot of the staff to organize the business of movies at the festival. It's very organized for business. It's for the people *and* for the business. Sundance? I don't know what it's for. But it's the biggest media event in the United States in terms of film.

Among films we've bought there, *In the Company of Men* was very successful. For us, the festival is incredibly successful to launch movies. We go in looking at it as a great place to position a movie in the marketplace. Just look at last year: We went with *The Opposite of Sex, Central Station, The Spanish Prisoner, Henry Fool*. All tremendous successes. I think we even had *Lone Star* there a few years before. We premiere them, and we got tremendous press on the movies and positioned them with exhibitors, everybody we wanted to.

On the other hand, we bought a film there—which will remain nameless—where if the critics had shown up and the publicist had been doing the job on the film, it might have had a different life. The people who were selling the film were spending so much time trying to close the deal that they didn't pay attention to the marketing aspects of the movie. So it got through the film festival, where the only major critic who was going to go see it was in the Library trying to get in the theater and it was so crowded and so overwhelming and so hot that the critic passed out and they had to take him away in an ambulance. So no critic ever *saw* the movie.

Barker: Filmmakers see that every year some film gets an unrealistic amount of money, and it's a totally false dream. So few films get picked up anyway, and to have this illusion that you're going to be the one to get several million dollars—well, it isn't healthy for the industry.

Bernard: The filmmakers are the big losers. They don't go to share ideas; they go to strike it rich. I hate to say it again, but it pisses me off.

I think a lot of movies are compromised by commerce. You find more and more stars who don't fit in parts in these films but have name recognition for the ancillary back-end deal. The other thing I find amazing is that if you're a man on the street [in Park City] you can't get into the movies.

Barker: *In the Company of Men*—it's so funny that it became successful, because it was so reviled when it was in Sundance. I remember someone crossing the street to avoid [the film's star] Aaron Eckhart, who was walking along. And Tom and I were looking at all this and saying, "If so many people hate this film, there must be something to it."

It took us a few weeks to come around to it. But it turned out to be the highest-grossing film to come out of the festival that year, and there was no bidding war or aggression like that which surrounded other films.

Bernard: And we got it for a very reasonable price because they gambled—like all these other filmmakers do—that they were going to get their *Hurricane Streets* million, and very few movies get that, and everybody else goes home.

Barker: We've got four films this year [going into Sundance]. Mike Figgis's *The Loss of Sexual Innocence*, a very personal film he's been working on off-and-on for many years. Very reminiscent of early Bertolucci, quite good. We have *Run Lola Run*. There's a movie called *This Is My Father*, which is a special entry; it's showing on Friday, stars Aidan Quinn, directed by his brother Paul, and cinematography is by Declan Quinn, and it's based on a story told to them by their grandmother.

Bernard: We have *SLC Punk*, which is opening night in Park City, and a party with the Violent Femmes in Z Place. Maybe we can outdo the Los Lobos evening.

Barker: I probably won't get in to my own party.

Voir Dire

"I think some of the writers have definitely paid attention to J. P. Donleavy, who, when asked what writing was all about, replied, 'What writing is really all about is turning the worst moments of your life into money.' "
—1999 dramatic competition juror Nik Powell

The competition at the Sundance festival—which certainly tries to project a laid-back image—has been decided in an atmosphere occasionally verging on the acrimonious. Sundance juries comprised of filmmakers and critics from around the world have been notoriously divided in the past, and it is not always the content or agenda of the competing films that sets the bar.

Doug Block, director of the documentary competition entry *Home Page*: Michel Negroponte, the director of my previous film at Sundance (*Jupiter's Wife*), is on the doc-

umentary jury this year, the irony being—I mean, we're good friends and all that, obviously I helped him with his film, but he's got a lot of integrity; he'll vote the way he sees fit. But the year we were there with *Jupiter's Wife*, Ross McElwee was one of the jurists and *they're* best friends and did two films together. It's such a small world among documentary filmmakers that it's almost impossible, if you've been around a while, to go to a Sundance and not have people you've worked with or friends or something on a jury.

For instance, I've met a lot of filmmakers who studied under Tom Joslin, the original filmmaker in *Silverlake Life*, who died in the course of making it. It's amazing how many filmmakers studied under him, who I've come across.

Sundance was *the* place to launch independent films, particularly documentaries, because the L.A. Independent Film Festival wasn't around at the time, and Toronto wasn't even Toronto then. Sundance was the only place to launch a *Crumb* or a *Paris Is Burning*, or the Errol Morris films. Where else, aside from the New York Film Festival, which is risky? Because if you get panned by *The New York Times* it's all over for you. And if you do the festival, Karen Cooper won't play you at Film Forum, which is probably the best venue for exhibiting a documentary. So there's all these things to think about.

The story is always that the documentaries are better than anything else at Sundance. And they're taken seriously. They do a great job of promoting documenta-

ries; Gilmore's always talking them up and he's really eloquent on it. He really, passionately loves documentaries and he's a great spokesman for them. There's also a hard-core audience that goes to them and supports them. They're always sold out. The bad news is when you're out there in the middle of it, the business end just doesn't care—it's just ignored by the distributors. Unless something generates unbelievable buzz, like that *Kurt and Courtney* thing, or *Hoop Dreams*.

It Was a Really Scary Thing

Amy Taubin, film critic, *The Village Voice*: I was a doc judge, the documentary jury, in 1991; it was one of *the* terrible experiences of my life—I'm glad I kept my sense of humor about it.

Also on this jury [was] Jill Godmilow (*Waiting for the Moon*), a person who I think has no mind and is an idiot. She and Barbara Kopple are the same person; they seem to bring a [similar] sense of moral values— you're on panels with them and they're telling you that films are immoral because they don't have uplifting endings. Anyway, there was her, the filmmaker St. Claire Bourne (*John Henrik Clarke: A Great and Mighty Walk*), and Marcel Ophüls (*The Sorrow and the Pity*). Now Marcel obviously thought he was too good for Sundance. Marcel came to make an alliance with me, except that he just had the *worst* ideas about American movies. He was one of these Europeans who liked anything that was exotic or mean without *knowing* any-

thing about America. And it was clear that I couldn't make an alliance with him because I didn't *get* him. But I tried to be nice.

Then we went to the jury meeting and the films that were of any significance that year were Barbara Kopple's *American Dream* (which I didn't particularly like) and Jennie Livingston's *Paris Is Burning* (which I liked a lot), and then various films that I thought were pretty dreadful, including *Coney Island*, made by one of those PBS guys, Ric Burns.

Not understanding that he was not going to necessarily get his way, Marcel came with *two* films to champion rather than one, so he was in a position of splitting his own interest . . . which was a pretty obscure interest! They were both these kinds of American grotesqueries: one was this film about Elvis impersonators, and I forget what the other was, but it was that kind of awful, "Let's get a couple of freaks and talking heads and we'll have a movie."

I spent my time negotiating. It looked like Barbara Kopple could have been the compromise winner, but the trouble was I didn't *want* Barbara Kopple to win; I wanted Jennie Livingston, and I think so did St. Claire. The trouble with [giving the award to] Livingston was that Jill thought *Paris Is Burning* was immoral—that it would incite or seize the perverse voyeurism of the audience, which would now come to see this film because we gave it a prize. They wouldn't have come otherwise? But we would be *encouraging* them; we would be encouraging their benighted voyeurism.

I was not going to be moved from *Paris*, and I kind of manipulated the situation over a very long evening—like eleven hours—so that we ended up splitting the prize and giving it to Jennie *and* Barbara Kopple together. I didn't mind giving it to Barbara Kopple if we could give it to Jennie, too.

So, juries are strange things. I've been on a bunch of juries but I'd have to say that was the strangest. And I think it has something to do with Sundance.

The only resistance in terms of the Sundance hierarchy was that Geoff Gilmore kept coming in and saying "We *really* prefer not to split the prize; we want to give one prize." But that was it.

That same year, the fiction jury had a very easy time of it. They were Gus Van Sant, Karen Durbin (a critic and editor), and Heather Johnston, who makes films with her husband Gordon Eriksen; Catherine Wyler was the fourth person. Gus preferred *Slacker* [Richard Linklater's comic portrait of Austin ennui], but everyone else wanted *Poison* [Todd Haynes's multistory meditation on gay themes] to win. And it was funny, because everyone assumed that it was *Gus* who pushed *Poison*.

But I think Gilmore had an absolute fit, because he had these two gay films—*Poison* and *Paris Is Burning*—and I think it was a really scary thing. The next year, there were all these indirect comments from Redford about how this wasn't a "gay film festival."

I think it's difficult looking at films the way they look at them—sometimes incomplete—and seeing if

there's something there or not. But at the same time, they don't seem to have anything they support. I don't think there is such a thing as "the Sundance film." Way back when they founded themselves, there was that kind of thing going on in a certain area of independent film, the gingham-dress-*Little-House-on-the-Prairie* kind of indie, and obviously that's where they saw themselves at the beginning. But when it started moving in other directions, I don't think they had a position after that. It just seems so purposeless in terms of what they choose. I think there is a certain amount of pressure that gets put on them and I think they're responsive to it (although they won't admit it); when certain people put pressure on them to take a film, they will, although they won't necessarily take it in competition. That's why they started the American Spectrum. I just think there's a kind of inertia that sets in as the thing gets bigger and bigger they have to find ways to keep those people coming back and so they look for a certain kind of film that might be salable.

I think there are all kinds of people who come there. There are people who come for the glam, I think there are people who want to go skiing and see a couple of movies; they know Redford's name.

But I also think if you look at it carefully, you'll see that the interesting films that have gone to Sundance and done well are East Coast films. But they have a real West Coast bias. So in general, with the exception I guess of Tarantino, they have all this West Coast *junk*. The West Coast indies I think are much closer to being

calling-card films in general than the East Coast films—although the East Coast indies are certainly going that way. I think it must have been difficult for them year after year to have the films that do well—either during the festival or afterwards—be East Coast films.

There'd been indies around for a long time, it's just that in the late seventies this kind of infrastructure was created, and I think of all those institutions Sundance is the most crucial. That's because it has the most real ties to the studios.

But I think it's kind of a disaster the way it's the only festival that *counts* for indies—the way people feel that if they aren't in Sundance, they don't matter. But I think there are other things that are even *more* disastrous: the way distributors read reviews in the trades are always couched primarily in terms of whether these people—who never see anything but studio movies—happen to think that an indie is commercial or not. I mean, that seems a much bigger disaster than the influence at Sundance: that you are dead if your film gets a bad review in *Variety*. No distributor will look at you, no one will go to your screenings. That's insane. No one reads the trades except other people who are supposed to be professionals and have minds of their own. But I guess they don't.

Elvis Mitchell, film critic and 1999 Dramatic Features juror: They treat jurors like gods. Oh man, basically, they were like, "Mr. Altman? Get the hell out of here! We've got *jurors* here!" I don't think of myself as corruptible,

you know, like I never wanted to be rich or famous. But having had a taste of privilege? All my socialist thoughts went right out the window. Let ME eat cake!

I'd never been to Sundance before; this was my first. Geoff Gilmore at one point just said they'd been thinking about me for a long time for the jury. I went, "Oh c'mon, please, you've been *thinking* about it? I'm not *that* hard to reach." So a week later he called and said, "We want to have you."

I'm happy to have gone this way, because people have said there's this real sort of schism to the festival now, because it's so much tougher to get in, so much more about buzz than it used to be, and it feels less responsive to the will of the people. There's more of this feeling of show business dominating the festival than it had in the past. [But] after I saw how it worked for jurors, I wasn't worried about getting in to anything.

I think there was more uncomfortable seating at Sundance than any festival I've ever been to in my life. The Holiday Cinemas? I didn't think they even had theaters like that anymore. As a juror of course you have special dispensation—you could bring in special pads to sit on if you wanted, or food—it really was incredible. I mean, I hate saying this 'cause it makes me sound like a Mercedes Marxist, but I loved it: "Oh, you're a juror? Oh, then it's OK, you can eat." It was really cool. And it makes me leery about going back, 'cause how good can it be after that?

The Players

The total roster at Sundance 1999 for the festival's competitions or sidebars incorporated nearly 200 feature-length and short films—which represented nearly 200 dreams of success for their creators, not to mention the struggles of hundreds of others whose work did not make it past the selection committee.

In addition to filmmakers interviewed for this book during the course of the festival, three directors—two Sundance veterans and a festival neophyte—were interviewed at various stages before, during, and after the festival week to examine blow-by-blow the process of bringing their cinematic vision to fruition, wading into the competitive waters of festival selection, strategizing their marketing of the film (and themselves), their reactions to audience and critical responses, and the negotiation of parties interested in distributing their work.

Gavin O'Connor: Tumbling Into *Tumbleweeds*

"I was afraid the film was going to fall through the cracks, and I really wanted a way to sort of gently usher it in. I was very grateful for that at the time, and didn't worry too much about whether we might be at the wrong festival."
—Kenneth Branagh, having premiered *A Midwinter's Tale* on the opening night of Sundance 1996

Gavin O'Connor's previous Sundance entry was the short American Standoff. *After helming the 1995 feature* Comfortably Numb, *he returned to Park City with* Tumbleweeds, *a road movie/character portrait that was invited into the Dramatic Competition.*

◑ ◑ ◑

Gavin O'Connor: I was with a woman, Angela Shelton; we were living together. And we fell in love. And she had written this Kerouacian stream-of-consciousness manuscript, essentially the story of her life, from when she was seven till she was seventeen; it was almost this diary depicting the life of her and her mom. They lived this very itinerant, nomadic lifestyle where her mother was constantly chasing men, chasing love, with Angela sitting in the car next to her as she found men. And yet as fucked up as it was, you couldn't deny the love they had for each other—they were so insanely in love

with one another. And through all the tragedies that occurred they managed to survive with laughter.

I sat down on the couch one day with the manuscript and wound up reading it for hours. I laughed, I cried, I experienced so many emotions. I said to Angela, "When it's finished, I'd love to make a film out of it." She said, "Really? Can I write it with you?" I said, "Sure."

So what we did was we got in the car and drove across the country, went to all the places where she lived, backwater towns, dusty little places, documenting it all with my camera. And we ended up in Washington State, where her mom was living. I was nervous—I'd never met her, but we spent many days with her, getting her perspective on their lives. We bought a dog out there, which was great; the dog came back with us and we drove through the South, to Asheville, North Carolina, where Angela's from originally. I met her grandmother, her aunts and uncles, then drove back to New York and dove into this.

I needed to focus on one age of the child, so I picked twelve, which for a girl is a pretty delicate age, on the cusp of being a woman. In the beginning [stages of writing] it was very difficult with Angela because she would say, "That never really happened." And I'd say, "No, but we're making a *movie*. It's the *spirit* of the thing." She was a little resistant, but she slowly began to see how it grows.

And finally, I got a draft I was fairly happy with and sent it to my brother Greg, who's my partner. He

Gavin O'Connor with actress Janet McTeer, star of *Tumbleweeds*.

read it and gave me notes. And I sent a copy to Ted Demme, who's a very good friend of mine. We sort of exchange scripts all the time. He called me up and left a message on my machine, and he said, "I'm sure you want to direct this and I'm sure Greg is the producer, but I love the script and would love to help you out any way I can." So he came on as executive producer, which was helpful.

So the next thing was, Angela and I split; it had sort of run its course. So she moved out to L.A. But we still had this child we wanted to give birth to. And I let about two months go by before calling her up and saying, "Listen, Angela, I can't let this go; I want to continue this." She said, "I do, too." The side story is that our relationship evolved into one of brother-sister-

confidant–best friend. Fell madly in love again, but in a platonic sense. So things were back on track.

At Least They Had the Balls to Say No

O'Connor: Teddy Demme had put us together with this casting director he works with, Avy Kaufman. She put together a cast list of actresses, names like—ridiculous, I know—Michelle Pfeiffer. I said, "Could we step back on earth here? That's not going to happen." And I didn't even *want* it to happen.

Well, we'd gotten a cast list, lots of B actresses, but in my head I had this concept of a documentary being wrapped in a drama. And I told Teddy, "I want to get an actress that nobody knows." He said, "Gavin, we'll never get the financing." But I said, "I don't want anybody to know this actress from any other roles."

So I put on *Charlie Rose* one night, because I wanted to see Janet McTeer—I'd read so many wonderful things about her performance in *A Doll's House*. I remember reading *The New York Times* review by Ben Brantley, who's probably seen ten thousand plays, and he called it the single greatest stage performance he's ever seen in his life. That's what he wrote. That's *serious!* So on comes Janet. I was expecting this English blueblood, arching-the-eyebrows actress, and out comes this ballsy, sexy ball of energy who was incredibly smart, incredibly funny, who sucked the air out of the room. She was so *not* English. And I'm watching and thinking, "*That's* Mary Jo. That's the character."

So we got her the script, and she responded to it; her agent called me up and said, "She wants to meet you. Why don't you come to the play? She'll have a ticket waiting. You'll meet after." I went to the play, watched a wonderful night of theater. I had some problems with the play, but her performance was exquisite.

We went for a drink afterwards. We sat down, sort of dancing around each other; she was probably auditioning me as much as I was auditioning her. But we really just got to know each other, didn't talk about the script too much, and wound up staying there till four in the morning eating, drinking, and liking each other. First couple of minutes sitting down I felt comfortable with her, almost the way you feel that you're from similar tribes. I felt we were from similar tribes.

I called Teddy and said, "I want her to play Mary Jo." He was cool with it; my brother was with me on it. I set up another lunch with her 'cause then we were going to meet the Miramaxes and Sony Classics and Octobers; Teddy was setting up all the meetings to get the money—a $3.5 million budget we wanted. Janet and I had our meeting to actually discuss the film and what I wanted to do with this movie and what I expected from her. I had a *lot* of expectations and I was going to be very hard and push her and if she's going to commit to this it's gotta be a hundred and ten percent or don't waste my time, and don't waste her time. We had this conversation and we walked away saying, "Let's do this together."

Then we had our money meetings. And everyone

was like "Oh, we love the script and Janet McTeer, *but* . . ." Everyone was like that. These companies are amazing. They function on such fear. People are so afraid of making a decision; they never said yes, but they never said no either. They just sort of left us dangling out there. The one thing I have to give Miramax credit for is that in one week they called up and said no. I told Teddy, "At least they had the balls to say no. I could be sitting here two years from now waiting for these other guys." That's insanity. I'd never do that. I'll kill myself before that happens.

Guerilla Time

O'Connor: I couldn't *not* make this movie now; it's like me being addicted to a drug. You know how when you have to pee really bad and you can't hold it any longer? That's kind of how I felt: "I gotta fucking pee, I gotta *do* this!"

So Greg and I sat down and said, "Obviously the $3.5 million budget is out the window; that's never gonna happen. How can we do this? Is Janet still going to do this with us, down and dirty? Guerrilla time?"

The thing is, we had become very close. *Doll's House* ended, she moved to New York, I helped her move in, we became very good friends. I told her, "Janet, this is what I'm doing, and if you still want to make this film with us, this is how it's going to be. There will be no

trailer on the set for you! I don't know what you're used to in England, but this is going to be a little ugly."

She said, "There's no way I'm not doing this. I'm in for the long run." Here she is, she's gonna get scale, SAG pittance, and I love her for it. She's loyal and she has integrity and she has nobility.

We'd gotten back in mid-September from shooting all over California. The first twenty minutes of the film is a road picture, and the characters wind up in this fictitious town called Starlight Beach, which we set in San Diego, and I didn't want to fake that. But the beautiful thing about the state is you can kind of fake the whole country—it's got farmland, beaches, mountains—so people will think we're in Missouri, when we're actually in some town in eastern California.

We submitted a rough cut to the festival, and it had a lot of warts on it. It was a little ugly. We were still in middle stages of the editing process and we had to submit it. I did a temporary mix, and in a feverish rush we laid in temporary music that a lot of times didn't work, or we used no music—I had no composer yet, so there was no score.

The irony of the whole thing is, we went out and did this thing down-and-dirty and it looks great, so *now* we're getting calls from Miramax and Fox Searchlight and October and Artisan. *Now* they're interested! They all wanted to see it before the festival. I said, "You'll all be seeing it at the same time. And I hope you like it."

But this Sundance thing, it's unbelievable. I am such a hypocrite. I've gotten down on that festival. I know

Kimberly Brown and Janet McTeer in the road movie *Tumbleweeds*.

films that I thought were really wonderful that didn't get in, and films that politically *did* get in. When a short film that I wrote and directed called *American Standoff*—a metaphorical story about what was going on in the Persian Gulf—got in, I was there for it. I could have showed up or not, no one cared, so I was on the side-lines sort of watching the cell phones, schmoozing, Hollywood descending on the mountains. But now, I constantly stop and go, "Man, we're really, really *lucky!*" *And* I'm profoundly *grateful* that we got in. Because luck plays a part in it. It *has* to. Someone responded to something in the film, and we got lucky.

Tumbleweeds is a very edgy film. But it's a buddy picture, too, about a mom and a kid, and we approached it in one way: we will always go for the truth, whether it's really ugly or not. Never wanted to senti-mentalize anything, just dig and dig and dig for the core. If I don't sell this film, I am immensely proud of it and it was the greatest experience of my life and I have not one regret. I think that's the most important thing. Whether we get a dollar for it or something else, it doesn't even matter. Really.

Although I'd *like* to get my money back.

David Riker: Building *La Ciudad*

"What you do has to be from the gut. You can't be swimming upstream, trying to lay your eggs in the rich sand of Warner Bros."

—The late director Frank Perry (*David and Lisa*, *Diary of a Mad Housewife*) while showing his *On the Bridge* at Sundance 1993

La Ciudad (The City) *is an omnibus fiction film derived from the experiences and dreams of illegal aliens and immigrants in New York's Latino diaspora. Born from a short film done at NYU film school,* La Ciudad *is comprised of four stories: "The Puppeteer," about the relationship between a homeless street performer and his seven-year-old daughter; "Bricks," in which manual laborers struggle to find common ground; "Seamstresses," about sweatshop workers; and "Home," about two teenage immigrants from the same small hometown village who meet in New York and fall in love. The authenticity of the stories was heightened by the use of nonactors in many roles, and by its black-and-white, documentary-style photography.*

Directed by David Riker (a 35-year-old documentary filmmaker who got his start as a photographer recording antinuclear demonstrations in the 1980s), the film was an entry in the American Spectrum section at Sundance.

David Riker

David Riker: I began, when I was much younger, as a still photographer. By the time I was seventeen, I really wanted to be a photojournalist, and I was steeped in a certain photographic documentary language. I set out to make my first documentary project in 1981, photographing the antinuclear movement. That project lasted for three years, during which I was also part of the movement as a student peace activist. I photographed it all over Europe, the United States, and Japan, and eventually assembled a serious body of work, hoping to join Magnum or Black Star, one of the agencies.

But around this same moment I had a powerful experience of looking at my work and realizing I didn't know any of the people I had photographed. In most cases I didn't know their names; in none of the cases did I have addresses or phone numbers so I could send them copies or have some ongoing relationship with them. I would photograph women camped out at the Greenham Common military base in England, survivors of the bomb blasts in Hiroshima, or families sitting on the road outside the Trident submarine bases in Bangor, Washington, and I didn't know *who* they were.

I realized also that the photos were potentially half-truths—or if not half-truths, they were very limited in their ability to express the story I was trying to approach. And I felt the need to be accountable to the people whose photos I was taking, to bring the work back to them and show the argument I was making with them, to see how they felt about it. And I wasn't able to do it. And so I decided to make film. I wanted people to be able to speak, to be able to *contradict* the photograph itself.

I spoke with one of my relatives, an older woman, and she was remembering her childhood in Massachusetts, where she and her mother worked in the textile mills, in a place called Lowell. The workers lived across the river, and she told me how at the end of every day, her mother asked her to make a choice outside the factory before coming home: Buy bread in the bakery nestled right beside the factory, in which case they had to walk across the bridge home. Or to take the bus.

In the winter, the question had a lot of meaning, because the wind across the bridge was bitter. And she said she almost always chose to buy the bread, and they would walk home together across the bridge.

And when she was telling the story, I looked at one of the black and white photographs of mother and daughter bundled up, with "Albion's Mills" behind them with black smoke coming out of the stacks. Everything about this photograph was about pain, suffering, the struggle of industrial labor. And she told me, of all her life, those were her *happiest* memories—walking home and anticipating the family's reaction that she'd brought home warm bread again.

I wanted to take that photograph, to film it, and have her approach the camera and *tell* us, "I've never been so *happy.*"

I decided to try and learn film on my own, and had an adventure doing that, working with hand-cranked Bolexes which were silent, and then using video, but at every stage I wanted to be accountable to the people whose story inspired the work to begin with. And this is the long way of saying I still want to have that accountability as a filmmaker.

You Live in the Shadows

Riker: *La Ciudad* came about because when I moved to New York to go to film school, I moved into a neighborhood in Gowanus, Brooklyn, that was largely immigrants. I was born in Boston, left at age four for

Belgium, lived there till I was nine, and moved to London. Lived in London more or less till my mid-twenties. I came back and made a couple of documentaries in New England, and from there I came to New York.

Arriving in New York, it was very powerful to see how the city differs from the city you see in films. The Latin-American presence in New York City is remarkable, not just for how extensive it is but for how *invisible* it's been in films. I couldn't get an English-language paper where I lived. I slowly started to learn about the community, which is really diverse and spread out all over the place, and when I wanted to make a movie about uprootedness, living a long distance from your home, I decided to set it in this Latino community—which I didn't know anything about.

The story took six years to make, not only because of money but because I wanted it to be a truthful document of what this community looks like, sounds like, and how they're living at the end of the century. At the beginning I made the decision that I wanted to use as many nonprofessionals as possible. The first part, "The Puppeteer"—which was my NYU student short—uses professionals, but in the other sections the vast majority of actors are immigrants, many of whom have been in this country a short time. Many are undocumented; most do not speak English, and asking them to work with me—not just to create the stories but to *act*—meant they crossed many, many lines.

I mean, the simple fact is, if you're an undocumented alien in New York City, you live in the shad-

ows. You leave your home in the Bronx or Corona, Queens, and come to Manhattan on the subway early in the morning, before the rest of New York is awake, and you're in the delis, the restaurants, or on the construction sites all day long, and then you go back late at night.

New York City is a hostile world for the new immigrant. They're constantly subjected to abuses that those of us who come from earlier generations of immigrants would never tolerate. So there's a lot of fear. Every night if you're watching the Latin-American news instead of the network news you get a feel for it, because every night are the stories of deportation raids, changes in the laws, families being separated. It's very palpable. It's like Tom Joad and *The Grapes of Wrath*. The migrants that are working in New York now are living that life but they haven't left Oklahoma; they've left Ecuador or Panama or Nicaragua or Peru, villages deep in southern Mexico. I wanted to stress that we're dealing with—trying to portray authentically, truthfully—what life is like for the Joads in New York City at the end of this century, the Joad families from all over Latin America, and all over the world.

The starting point is they live in fear. They don't speak English. Any time they interact with a gringo it's an abusive relationship—it's the INS, a police officer, an abusive boss. It's an atmosphere of total mistrust. How the hell is a director going to develop a relationship not only of trust and understanding, but a working relationship where they can be in the film? That's why

it took so many years. And why it's also the part of the film that I'm most satisfied with.

Above and beyond everything else, *La Ciudad* is a truthful statement about what life is like for this community at this time, in this place. It's not *my* vision of what their life is like. It's very much *their* self-portrait. The stories themselves have been generated by them, presented to them before filming began. They inhabited the characters and changed them; the dialogue is their own. The collaboration was so extensive that the finished film has a great level of truth, and each story has at least one veteran actor who becomes my main partner in the dramatic workshop that allows a group of garment workers from Ecuador and Mexico to become actors.

"Make It into a *Real* Film"

Riker: The original segment (which I now call "The Puppeteer") I originally called "The City" at New York University, where, among other things, I was strongly discouraged from making a foreign-language film—no, they said "foreign film." But when the film was done it won their film festival and had a very strong reaction—culminating in its winning the gold medal in the Student Academy Awards.

I went to Hollywood for the first time and met with Hollywood agents, executives, production companies, all of whom thought it was a great film. They loved the relationship between the father and

La Ciudad, clockwise from top: Marcos Martinez (Armando) is a day laborer in "Bricks"; Silvia Goiz (Ana) is a garment worker in "Seamstress"; Cipriano Garcia (Francisco) and Leticia Herrera (Maria) at a Sweet 15 party in "Home."

daughter, who were homeless puppeteers, and [said] how we should make it into a "real" film, a feature-length story. I said, "I don't want to remake this film about a father and daughter. I want to make a film about a community that is broader than a single narrative, and I have an idea of linking four or five separate stories. . . ." And of course nobody was interested.

I came back to New York and there was a month or so where I myself hesitated, and I started researching a feature-length story for "The Puppeteer": at the very point in the short where the father brings his daughter to school to register her, he has one of his TB coughing attacks and the school brings in a social worker and they learn that the family's homeless and they decide to put the girl in foster care, and they learn that the father hasn't been taking his TB drugs so they put him in the special lockdown unit on Rikers Island. They have a whole series of tuberculosis bubbles there. So I went out there and started researching the escape records to see if people have ever made it. Rikers, of course, says no one's ever escaped, but I began researching prison stories from other parts of the country and kept finding stories of prisoners being caught in Florida or Texas who *had* escaped from Rikers.

I devised this whole feature-length approach to it and realized that I didn't *want* to tell the story of a puppeteer. I wanted to tell the story of a community, which poses a couple of problems: one, that you have

different people who will never meet each other engaged in struggles that are very similar; two, that this community is very diverse—it's not as easy to describe as a "Mexican community" or a "Puerto Rican community." So I consciously decided to try to make three more stories that dealt with the complexities as much as possible. So that the way they were speaking—the Spanishes they are using, the dialects or accents, the countries they come from, the physical characteristics, from white to black—all these were conscious efforts to make a film that can also stand as a documentary record.

The basic outline for the stories occurred before casting began. The ideas for the stories came through preliminary research which involved hundreds and hundreds of interviews during which I looked for common threads and issues. I was being guided by the people I was interviewing. For instance, when I asked the women who were exploited garment workers what the most difficult part of their job was, they didn't say not getting paid—they said it was being away from their children. So then I knew my responsibility was not to make the political story of the garment worker who hasn't been paid, but to make the social story of a woman who is a long-distance mother. And I had meetings with a broad community of garment workers to see whether that story line was acceptable.

When I cast for garment workers or day laborers, I would see thousands of workers, meet and photograph

hundreds of them, and eventually pick twenty or thirty faces, of whom I was going to choose five or six. And I made decisions according to where they were from—the mountains or the coast, what their physical characteristics were like, et cetera. For most people watching the film it's not going to mean a great deal, but it's very closely researched.

The women who are garment workers are almost all Ecuadorian or Mexican. Why? It's baffling. The first time I went out to check what's called the River of Workers—anyone who works in the Garment District knows it. There's about a fifteen-minute period around seven-thirty each morning where from the subways there is a river of—primarily—women who are coming from two very specific regions of the world: Puebla in Mexico—and within Puebla, very specific villages—or Cuenca in Ecuador, a highland area. And in both places the women are relatively short, and have long hair pulled back that falls to their waist. To me it was extraordinary to go see this the first time; it's very powerful.

But it's the same experience of all previous waves of immigrants to this country, whether we're talking about Eastern Europeans, Sicilians, Irish—the way villages, very specifically, organized new homes here. It all makes sense, because the first person comes, writes home, others come. The immigrants live that way now; you have people from a particular village who live in six different apartment buildings in the Bronx.

It's an *American* Film

Riker: In late August, *La Ciudad* was invited to the Los Angeles International Latino Film Festival, Eddie Olmos's festival. They offered the film the closing-night spot and made it clear that they were going to give the film a chance to play in front of a very broad sector of the Los Angeles Latino community.

I knew immediately that if I did that, the film would be excluded from the competition section of Sundance, because those have to be U.S. premieres. It was a difficult moment. I even tried to see if I could get Sundance to see the film, but Geoff Gilmore was literally on a plane to Toronto when I had to make the decision; there was no way he was going to be able to see it in Toronto until our screening two or three days later. I had no previous relationship with Sundance, nothing I could say to people. And I made the decision to forsake Sundance for this Los Angeles Latino festival.

It was a difficult decision for me, but for *La Ciudad* it was an easy decision. The film ought to have screened for a Latino audience before anyone else. That's how I felt, and I don't regret the decision. Also, at that time I had no idea that it would be accepted into Sundance at all. If Sundance had told me, "Look, we love this film and we're thinking about it for competition," I would have gone to Eddie Olmos and said, "Can we show it in a way that's not part of the festival, maybe as a sneak preview?" to see if something could be

worked out. But we did the L.A. festival and there was someone there from Sundance, and Eddie Olmos spoke of this decision and thanked the people at Sundance for still being willing to consider the film for American Spectrum and not punish it for meeting its own constituency.

And the way things have worked out, I think it was the right decision.

I'm unhappy that it had to be an either/or situation. Festivals want to have fresh films; it's understandable. At the same time a lot of the festivals that would be relevant for independent film, whether it's a gay/lesbi-an–themed festival or an indigenous festival, are not going to really pose a threat to the Sundance program. So in the long term, I hope they'd reconsider, and let a small film play to its own constituency before going to Sundance.

Also, I'm going into Sundance very unsure of how the film is going to be received there, partly because my understanding is that the audience there is an industry audience, that it doesn't attract a lot of the people who live in Park City year-round. In Havana, for instance, the festival was for people who go to movies.

Jeff Dowd, Los Angeles producer's rep, on *La Ciudad*: He showed it at the Latino festival. After the film, he got up at the Paramount—picture the big screen, house about eighty percent Hispanic. There's a band and food in the lobby and we all figure this is going to be a

quick "Thanks for coming." But he took a couple of questions—"How'd you make this movie?" "*Why'd* you make this movie?"

And he started talking about his childhood. How he'd been uprooted, felt uprooted. How this was a movie about uprooted people. And he told them about how he'd worked with his actors, and started telling the audience about how he asked them to draw pictures of their mothers, guys who are like forty-five years old: "Draw a picture of your mother." And when you're not an artist and you draw a picture of your mother, you draw it like you were still four years old. So they draw pictures of Mom and these guys are breaking into tears. David had gotten them into this emotional space.

The reason it feels so real is that it *is* real—because of the stuff you don't have the luxury to do when you're making a low-budget film with a twenty-one-day shoot—or for that matter, a studio film with a bunch of stars.

Anyway, the audience was in there for forty-five minutes afterwards.

He knew going to the Latino festival was going to keep him out of the Sundance competition. He had to make a choice, and I think it was the right choice. And Gilmore was friendly about it, but he said, "These have to be the rules." Oddly enough, everybody was a good guy on this one.

David Riker directing a group of day laborers
in the "Bricks" segment of *La Cuidad*.

Riker: I am enthusiastic about going to Sundance. It's very significant for the film that's it's been invited to this mecca of American independent film. It's important because I don't want the film to be looked at as a foreign film—because it's in Spanish, and deals with an immigrant community. It's an *American* film. There's no film that's *more* American, because this is a country of immigrants who've gone through very similar stories. So Sundance's inviting *La Ciudad* is very important. I'm not sure how the industry is going to react, but I'm excited it's there.

The fact that we've now been invited to screen the film in a church on Sunday night after the Spanish Mass, in the shadow of Sundance, is very exciting. It's one of the things I'm most looking forward to about being in Sundance. Because the thing is, this Latin-American community is in every part of the country. It's not just in Los Angeles, Chicago, New York, Miami, San Antonio. It's in Kansas City, the meat cutters in Minnesota and the chambermaids in Las Vegas.

It's a Waiting Room

Riker: There always has been a vehicle—a journal or newspaper—that has served to focus the discussion and arguments about what defines a particular experience or initiative in film. They're very important, not only [for helping filmmakers] define themselves in opposition to what a certain understanding of what cinema is in their country at a given time, but they're also really working out internal differences.

Those debates in Latin America, in Europe, the new Czechoslovak cinema—the debates are very, very lively. But there's a real basis to the discussion. And the American independent film community—I'm not sure what to call it exactly—is without a basis. We haven't shaped our identity through that kind of focused argument or discussion within a vehicle that reflects it. Rather, it feels to me that it's come from somewhere outside ourselves.

There's actually a couple of ways to talk about this. One way is to say there are people who are striving to make very personal films, who are, by necessity, spending the early part of their careers struggling to pull money together. They accept the idea that they're part of an independent film movement, or community, but their involvement with it is not energetic.

Then there's the phenomenon of people who are independent only because they haven't yet been able to work in the more mainstream industry. And we see over time how quickly these filmmakers can move

out of the independent scene—even while they're in it, they're striving to get *out* of it—and because of that there's no heart, no core to this community. Sundance is probably the most important single event in all this, and should have had for ten years now a journal where filmmakers [could have] these debates.

You can't define American independent film on the basis of some kind of even, broad vision. *Clerks*, for instance, is objectionable in every respect to a director like myself; it's not a film I can identify with. And yet if my film were to have a good life within this independent film community, then at some point I would find myself sharing an identity with the director of *Clerks*.

It's a very uncomfortable relationship. And I need to be careful as well; it's not my job to criticize the work of other people irresponsibly. But what I'm saying is there's not a tradition among independent filmmakers of being accountable to the work or debating these questions, so if you want to do that, as I would like to, you end up feeling isolated. I feel very isolated within this community.

People will talk about the independent film movement being started by John Cassavetes, like it's this mantle we can wear, but you can't trace any lineage to that. What there is, is an absence of a true identity based on the nature of our work. It's a waiting room, by and large, to be able to get more secure financing.

Sundance is more than the festival. It's these direct-

ing and writing labs, and a lot of strong work has been supported there. I didn't go through there but I know people who did. *El Norte* was one of the first that was workshopped there, and—more recently—Chris Eyre's *Smoke Signals*. But I would feel more secure talking about being an American independent filmmaker if these directors had a place where they were really in debate over what their work means, what it is they're trying to do. Other people are having such discussions all over the world.

When I went to NYU's graduate film school, the people there made it clear: "We will not be talking about why you're making the films you're making, what the consequences are, or what they mean. All we're going to talk about are the technical issues involved." We were discouraged from discussing each other's work as it was being produced, even though you'd think the technical aspects were fundamentally tied to what a person is trying to say. But it just wasn't part of the education.

I'm not entirely sure how this has developed, but Sundance is an extremely important force in giving shape to an American independent community—to the extent that we *can* talk about it. They've become the most important festival in the United States and probably the second most important on the planet. People's production schedules, funding cycles, are being organized around the deadline; filmmakers rush through their projects sometimes to get their films there. Yet it's not fostering this kind of argumentative space or place

for discussion, and I feel uncomfortable not being able to discuss certain issues with other filmmakers and why they're making the choices they're making. Sundance is not a forum, and I wish it were. But it *is* supporting good work at the same time.

Jack Warner and his brothers had their ideology, what they called the "three *E*s," a checklist that they had to meet with every film they made: the first was Education, the second was Enlightenment—a very lofty idea!—and the third was Entertainment. Where did it come from? Why have the ideas of enlightenment and education been associated with film from the beginning? Because it's a pedagogic tool, because it is making an argument that influences the way people look at the world. People can ignore it, but it's a fact, bound up in the history of cinema.

And at the end of the century we find ourselves in the United States, where to talk about Education or Enlightenment is to ruin the party: "Our job is to entertain."

I don't accept that; my own experience doesn't allow me to accept that.

Films *distort* our view of the world, they shape our understanding of each other whether we like it or not; whether we're laughing or crying in the cinema, we're being profoundly *changed* in the way we think. This is evident, even within the American independent film history, because underrepresented communities have had to fight *against* this stereotypical distortion that's been perpetrated by film. So it's impossible to say film's

job is to entertain, because when we look at certain films that were extremely xenophobic, extremely racist, the whole history of films about Native Americans—we can have a certain critical capacity to look at them now, but whether we like it or not, film is not just about entertainment. We have a job to do that's not just entertaining. If it were simply entertainment we could say, "Well, nothing hurts anyone. There's no real consequence to our work." That's not true. Even within the whole Sundance initiative we see that part of it is to compensate for a distorted legacy that Hollywood has produced in representing who we are as Americans, et cetera, et cetera.

Whereas before we had the three *E*s, we now have *one E*, and within this young, nebulous association of independent filmmakers it's very hard to have a discussion about these other two *E*s.

Clearly, a film has to be compelling for people to watch, and every filmmaker has that responsibility to find a way to make people want to watch a film. But the purpose for making it should be more than purely entertainment. And the best cinema, the classic films from all parts of the world, have more to them than [being] strictly entertainment.

The unspoken rule, the invisible agreement, is that the market will decide. If a film does well in the market—if *Clerks* manages to make $2 million, a good earning for an independent film—it gets a stamp that it's a great film, a very important independent film, and at the Independent Spirit Awards this film will then be-

come a touchstone. But I do think it is an abdication to allow the market to have this will that we ourselves aren't willing to have, to criticize our own and each other's work not just on the basis of whether it's enjoyable to watch but what it is saying.

So I'm personally committed to being accountable for my work, on a daily basis.

Doug Block:
Erecting *Home Page*

"You get here to Sundance and you realize that the year and a half you pumped into your little low-budget film was not in vain. People *do* care. People do hear what you want to say."
— Edward Burns, director of *The Brothers McMullen*, Sundance 1995

Doug Block is the director of the competition documentary Home Page, *which is about the untamed frontier of the World Wide Web and, in particular, pioneering Web celeb Justin Hall. A Sundance veteran, Block also occupies the unique position of having made a film that—unlike virtually every other documentary—is more about the future than it is about the past.*

Block came into the festival with a certain degree of self-generated buzz, in that the entire three-year-long process of making Home Page *was publicly documented—quite appropriately—on his own Web site, www.d-word.com.*

❍ ❍ ❍

Doug Block: I've done Sundance three times now, twice as co-producer of films that were in competition. One, in 1993, was *Silverlake Life: The View from Here*, which won the Grand Jury Prize and Freedom of Expression Award, which Playboy gives out. I made the mistake of asking at the awards thing whether I'd get a free subscription.

To my wife's chagrin, I've gotten a free subscription every year since. They just keep coming!

And then I was coproducer of *Jupiter's Wife* in 1995. Those films were shown everywhere. They all got theatrical distribution, first on the festival circuit and then [they] got a theatrical distributor, and each played TV, or some aspect of TV, either very soon after, or first. It's a really tricky thing with documentary film—I'll probably get into it with my film 'cause I'm navigating that slippery slope now.

On *Silverlake Life*, Tom Joslin, the filmmaker, was one of the couple dying of AIDS, so he knew the chances of finishing it were remote; and part of the aesthetic was about him surprising everyone and dying first. And his lover, who wasn't a filmmaker, picked up the camera, and was doing those scenes on the deathbed. And then he didn't know what to do with the forty hours of tapes lying in cartons.

Then eight months later *he* died and the tapes were willed to my friend Peter Friedman, who's an editor, to put it all together. And there's that aspect of "passing

the baton" on that actually came through in the story-telling of the film.

I'll never forget the day I wound up getting involved in the film. Peter came back to the U.S., and I think I was the first person he showed this half-hour segment to—it was the first fifteen minutes of the film and the last, including the death scene. And I just sat there mesmerized. It was after my first feature, *The Heck with Hollywood!,* had come out, and I was trying to get another project rolling along and was looking for a producer—we all do this stuff so we can find a producer who'll fall in love with your work and raise money for your next film and will then do all the shit work and so you can go off and be the creative artist.

Peter had gotten money from Channel Four in Britain and he was doing it as a TV work. And before I even knew what was coming out of my mouth, I said, "This is crazy. You have a feature film here, you're thinking too small, we need to raise more money, transfer it to film. Sundance is like ten months away; aim to get it done by then and go for theatrical distribution. And I'll help you."

And I said this within five minutes of seeing it. I didn't even know what I was saying. He took me up on it, and fourteen months later—it was just death. It was really so hard.

With *Silverlake Life* there was a lot of interest in it theatrically. It was picked up by Zeitgeist, but *P.O.V.* [the public-television documentary series] wanted it for its season premiere, which is in June—this was, like,

Doug Block

February. And we knew if we took it, we had, like, three months to get it out, because after *P.O.V.* it would be pretty much dead theatrically.

Or we could have blown off the premiere—they were willing to do it as the last show of the season, but it doesn't get nearly as much exposure. Ellen Schneider, who was doing *P.O.V.*, loved it, felt it was her life's mission to get this film out, and we knew she'd do a great job promoting it. And it was so important for us to get it seen widely. We had a really tough decision. They were actually pressing us not to do *any* theatrical, and we said, "No way." And they said, "OK, but not L.A. and New York," and we said, "No way." Finally they said, "OK, no New York." So we opened it in L.A. and got spectacular reviews—the *L.A. Times* said, "This

will change your life"; it was a serious review, you can't get better!—and won the L.A. critics' prize that year for independent film.

Zeitgeist made seven or eight prints and it got out to eighty cities in three or four months, and we were on Cinemax, the premiere of *Reel Life*.

But it was a little heartbreaking passing up New York, where people still don't know about the film in the same way as L.A. I actually went out to the critics' award thing and all these people who were getting awards that year, Holly Hunter, Spielberg, were coming over after the speeches and telling me how moved they were by the film. And I was like, "Oh, yeah, I like your films, too. . . ."

Find Out What People Will Give You and That's Your Budget

Block: HBO is one of my funders, which was kind of sealed when we won an Emmy for *Jupiter's Wife*. HBO was at the next table and they said, "You know, we *really* want you all as part of our family." And we said, "Well, we've been looking for a foster parent."

I have a lot of respect for them, and Sheila Nevins; if you look at the list of top documentaries of recent years, they've been involved with half of them, at least. They're not easy to deal with, but they do great work, and in my case they left me alone to do it. From the beginning, they looked at my sample, and Sheila said, "It's quirky; I don't normally like quirky. But I like this.

But I don't know how to deal with quirky, so I'll leave you alone to do it." They oversee fifty films, so it's not like they want to be hands-on with everyone.

They basically trusted me; they left me alone to do it, and what more can you ask?

With HBO you get the money piecemeal or you get fully funded and you battle over copyright, but they basically have ownership of the back end. I understand they've been known to take over personal films and recut them. So I was very wary of getting involved to that level because *Home Page* is a somewhat autobiographical film and the last thing I was going to do was relinquish control of it. But I've also heard from filmmakers who've had the same deal and were left alone as well. So part of it depends on their respect for you as a filmmaker and probably how tough you are in standing up to them. Things like that.

With Cinemax, they only put up part of the money. Usually it's a little later down the line. It's technically completion money, although they'll do it at different times. So it was about a quarter of what I wanted and maybe a third of what I needed. Budgets are kind of a dream world in documentaries anyway. Find out what people will give you and that's your budget.

Sundance helped *Silverlake Life* a great deal. It was a film that took a lot of people by surprise. I don't think they'd ever seen anything like it; it may have been the first film shot entirely with a camcorder and transferred to film that got out wide theatrically. In that regard alone, it was a hugely influential film. The year before,

1992, there was a documentary panel where the film-makers were complaining about the ones that had been shot on video and transferred to film. They didn't think they should be judged the same way. Well, the next year we won the Grand Jury Prize and there wasn't one comment made about "This is a video, it's not really a *film*." It just ended the discussion right there.

And once the articles about the making of it got out in places like *Filmmaker Magazine* and *The Independent*, it was like—well, Gilmore said the next year, half the documentaries submitted had been shot on video.

The press picked up on it; it moved everyone who saw it. I think everyone realized the importance of it, and I think artistically it was a successful film—the diary form kind of got reinvented.

Crazy Things Happen

Block: What might have been interesting with *Home Page* would have been someone like Michael Moore (*Roger & Me*) doing the same film with someone like Justin. I was always really aware of the etiquette of documentary filmmaking and where that compares to what someone like Justin's doing, in terms of invasion of privacy. How do you get people's permission and make sure they know you're coming with a camera—that you're coming from a certain place, in terms of getting you to trust them, that you're going to be fair to them?

I was very, very careful of what I said to him. I didn't communicate with him nearly as much as I prob-

ably would have [with] other people. Because I *knew* anything I said to him potentially could end up on his Web site. I knew I could say something like, "Don't write this up on your site, Justin," but I didn't want to operate that way with him. I wanted it more like, "OK, I'm going to censor myself because I don't want to tell him not to write; I don't want to be in that position." Just as I don't want him saying, "Don't use that in the film." In fact, I wanted that tension to be part of the film. I thought that was really interesting when he grabbed the camera and started asking me questions. I wanted to see what it felt like. In fact, I was surprised that he wrote so little about me and the making of the film in his journals.

In my director's statement in the press kit—which I've posted on the Web, by the way—it's all about the interrelationship of the Web site with the film, how it became about my need to reveal myself. And once I got into it, how far would I go with it? What about myself? Of course, I'm coming from a different place, a long-term relationship, a wife, a kid, other factors these young kids don't have. I have a different take on it. I'm a little older. But I thought the contrast was good.

Nobody quite knew what was going on; the Web was so new and experimental. Did Justin know he was going to have thirty thousand daily readers? He was twenty years old. Crazy things happen. He told me at the beginning, "You put a Web journal up and just keep doing it, people will find you. It's amazing; they *will* find you." And they found me. Journalists found

Justin Hall, the enterprising Web celeb of *Home Page*.

me. There was almost this trail of word of mouth. And I stuck to this attitude that, "I'm not going to promote myself because I'm making this movie, but if somebody finds me through the Web site and wants to write it up, I'm not going to stop them."

And one by one it happened. I've had more press about the film before it opened than any other film I've had even *after* it's opened.

My wife turned to me after watching it and said, "It's really clear to me that you were having an affair with the Web." I said, "Yeah, the Web was my mistress. And I had a little affair and had fun and got my rocks off, met all these interesting young people, and then I wanted to come home." She knows me better than most audiences. My daughter wants to be in my next film, of course. But my wife's reaction was a little more

complicated, because of how she got in it: she came into the whole film really late in the process. I think it was only at the tail end of the rough cut that my editor and I decided we needed her in it. How could we be doing this film about intimacy and real-life relationships and everyone is in it but my wife? *Hello?*

At that point we were getting along very well, and the editor suggested I wait till she was really pissed off at me, 'cause we needed that tension.

You can be happily married, but there's this faint idea that there's someone out there who'll get your blood racing again, and the Web gives you access to that: you start writing e-mail back and forth and sharing your soul. And in your mind everybody looks like Michelle Pfeiffer—and not the overweight teenage boy you're really talking to in Akron.

I don't think the whole experience made me feel old so much as it made me feel I wanted to be young again. College isn't a period I look back on and go, "God, I wish I was in college again." When I was younger I knew I wanted to make films, but films seemed so impossible to make when I was twenty because they just cost a fortune. There were no digital camcorders that cost two thousand dollars. But for someone like Justin to have access to this outlet, where you can actually build an audience—I liken him to one of the most overproduced cable access shows ever. It's not like people all over the world were gripped by it, but among the people on the Web he had a really sizable following. And because he was publishing every

day people came back regularly, to the point they got upset when he missed a day.

That notion of celebrity, while it's inspired a lot of people to make films, it brings an awful lot of people to make films for the wrong reasons. Now the media just totally feeds into it. Sundance is a big part of that. I don't think it's the fault of the organization at all; they run a good festival. But ever since *sex, lies and videotape* there's been that mania—and it's not just the Hollywood types; it's the media—of finding a star, of looking for the Cinderella story. It hurt us directly in 1995 with *Jupiter's Wife*. Bernard Weintraub of *The New York Times* did a long interview with us and Michel that was going to play in the Monday Features section after the festival—they always have some highlight thing and then get into the winners. Well, that all went by the wayside when *Brothers McMullen* won and the story was, "Two weeks ago he was a PA on *Entertainment Tonight;* today he's the prince of Hollywood!"

I remember going backstage after the awards and there was Samuel Jackson complaining to everyone within earshot that nobody on the jury wanted *Brothers McMullen* as their first choice. They were split between *Heavy* and *Rhythm Thief* and they split those into other awards. *Brothers McMullen* was a total compromise choice. And that's all you hear about now. *Brothers McMullen! Brothers McMullen!* Nobody liked it. Certainly nobody *loved* it.

But then everybody just jumped on it. And I think a more talentless filmmaker is hard to find. His second

film was so pathetic. My wife and I rented it on Valentine's Day thinking this was going to be a nice little romantic thing, and we sat there with our mouths open. He's actually not a bad actor; he did *Saving Private Ryan* and all that. And I wish he would stay there. Clueless as a director and one of the worst writers going.

So that's the aggravation.

It was wonderful to see [the buzz] happen with *Hoop Dreams*, 'cause it's rare that documentaries get that kind of attention. It'll be interesting at Sundance this year, because it's going to happen with *Sex: The Annabel Chong Story*. Mark my words. Nobody will be talking about any other film for the entire first half of Sundance. Two weeks ago they told me it had sold out for every screening: "Everybody's talking about this movie *Sex*. Oh, yeah, they're talking about your movie, too."

The media attention, there's no other time of the year where the entire world descends on such a sleepy little town. I think part of it's the cachet of Redford himself, the perceived glamour. It can't happen in Telluride 'cause there's no celebrity there that gives it the cachet. For mainstream audiences, if *Entertainment Tonight* is going to go in with their cameras, it's, "Oh, my God, Redford's festival!" It puts it on another level of glamour.

The other by-product of that is, I was done with this film basically in June, we got some feedback that it was a little long, but after the fourth screening with audiences we knew where it was long—and there went all our money in making another transfer. But when

Sundance told me it was in, I said, "By the way, it's fifteen minutes shorter now." They said, "Oh, OK, well, everybody felt it was a little long but really worthy anyway." So not only shouldn't they be editors, they're not *trying* to be.

That's the other thing about Sundance. Everybody gets a publicist. You almost can't compete without one. You won't even be in the mix. All we ask for as a filmmaker, at least all *I* ask for, is to be considered. Be put out there properly so people can make up their own minds. God knows, *Home Page* is one of the first serious things out there about the Internet; it's gotta be the first film where there's this interaction between the Web and the film, to the point where audiences seeing the film can go to the Web afterward and not just catch up with every character in it and what they've been doing—because they all have these amazing Web sites—but interact with them, e-mail them, talk about the issues the film raises. Or tell them to fuck off, whatever. We're inviting you to do it. That's why we ended the film with the URLs. At the screenings we're going to hand out postcards with the URLs, 'cause we want that kind of interactivity. The people in the movie are psyched because there's this idea that they're going to get all this traffic now.

I'm excited about it, because it's still somewhat experimental. We don't know where it's going to lead. But as Justin said, "Attention is the commodity of the Web." 'Cause it sure isn't money.

It's all brand-new. Everybody talks about media

convergence, and here comes something that I hope works as a stand-alone film, but which might also intrigue people enough to get on the Web, read my three years of journals about making the film—which is all linked to various other writings by all the people in it, or writings about the Web or what people have written about the film. It's a very rich cross-pollination of media.

It'll be interesting to go out to Sundance. We have to put the film out there, but we're also trying to intrigue the press about this project, which really is an example of experimentation and play and convergence and the direction movies will be going. Is it a Web site or is it a movie? The Web site's going to live on long after the film is over and sitting on a shelf. I probably put more energy into the Web site than the movie in a lot of ways.

I realize that I captured a time that is now history. We put a supertitle in at the beginning that says "1996." And I think it will resonate more now, knowing that it was only three years ago but it's already history.

I Want to Treat It Like It's the Last Festival I'm Ever Going to Go to

Block: We have to contend with the *Annabel*-ization of Sundance this year. But on the other hand, because the Web is more in the mainstream, and journalists are aware of it, it's not something to be threatened by. I'll

be curious if it has any impact out there. Obviously nothing tops sex, but short of that I think I have an inherent advantage over the folks dealing with social issues. It's the time-honored problem of documentaries, getting attention for a serious documentary. I've been lucky in that the films I've worked on have all worked as stories. It's always been my interest as a filmmaker to tell a story, or to get at issues, some question, through a story and characters. So oftentimes in the past we've had these really good films that people started out not wanting to see, but they hear that it's good and they wind up going. But it always remains a documentary.

It being a personal film, I'm a little ambivalent about Miramax coming in and doing the "Miramax treatment," people lined up around the block to see it. I mean, I'll take it over the alternative, which is an empty theater or not being in a theater at all! But I'm not sure that's my dream, either. I don't really know what I want. I wouldn't mind being well paid for it; that would be really nice after years of not even drawing a salary on it. But I've never worked on something before that has the potential to hit an audience as widely as this one does.

Or to be as exciting to people who go to a Sundance looking to discover something. The reaction could run the whole gamut, so I'll be really curious. The wild card is having Justin out there; I think they'll go crazy over him when they discover him. I love the idea that he's going to get all this attention. He'll take any pressure off me—MTV at one point wanted to follow me around

with a camera. I said, "Look, you don't want me—you want Justin." He's there to deflect the attention. If anybody writes about this, they're going to write about Justin.

American Hollow I hear is a great film, but it's about poverty in Appalachia. You can't make that sexy. And Rory [the director] doesn't want to play on the fact that she's a Kennedy. That's her publicity angle, and I'm sure she's not into playing that up. You go down the list and I'm sure most of them are really well-made, compelling documentaries that are going to sell out and do well and they'll have their Sundance day in the sun, which is great. 'Cause you have very few other rewards as a documentary maker—it goes out and evaporates into the cultural mist.

It's not the same with me as with some feature filmmaker, especially if they're young. So many filmmakers go in with the idea that it's "make-or-break": "This is my career on the line; I have to win a prize. For me to win, everybody else has to lose. If I don't get the deal here, I'm dead in the water."

You've never seen such long and gloomy faces as on the plane ride home with the filmmakers who didn't win prizes. But as someone who's gone home having won prizes, it ain't that great. You know you always find something to complain about—"Yeah, we won a prize, but no distributors came to our screenings."

But, you know, I am solid now about being a documentary filmmaker. If Miramax picks it up and it gets out widely, that's great. But Miramax is not funding

my next movie, 'cause I'm making a documentary next, not looking to go out to Hollywood and cross over. HBO, they were going to do a poster and put HBO all over it, and I said, "Thanks, but let's save this for later." I'll downplay their role in it now, because we're trying to interest a distributor and you don't want them worried that it has to air on cable first.

At the same time, HBO are the people I want to work with. They are going to fund my next movie. They are the champions of documentaries, and it's really important to go to Sundance clear on what you want from it, not getting seduced by the pipe dream of Harvey Weinstein buying you a Stoli at two at the morning and throwing a three-picture deal in your lap and saying, "Sign this in an hour or we're not interested."

I don't even know what it's about except that it's a validation of you as a filmmaker. Maybe all the validation you really need. You know when people say the Oscar nomination was the thing, that it's not winning the award? There's a lot of truth to that. You just want to be taken seriously as an artist, as a filmmaker, and all your friends and family know what Sundance is, they've all heard of it. If you get in, it's like you've been nominated for your Oscar.

So I'm really going to enjoy this one, in a way I haven't enjoyed the others because I was so hung up on getting results. Wherever I was I always thought the party was somewhere else. The important people were somewhere else; the important distributors were some-

where else. And they were! Two years ago when I was out for a panel, that was the year the Brian Wilson/Beach Boys documentary came out [*I Just Wasn't Made for These Times*] and he played in one of the bars. Everybody knew. Redford was there. I was across the street having a cup of coffee. I didn't even hear the music. I thought that was a pretty apt metaphor.

But not this year. Everybody's coming—Justin, my producers, the editor, the sound editor wants to come, crash on the floor in a sleeping bag. My associate producer's coming out for three days. They're so excited, and we're going to have a great time, thoroughly enjoy it. I want to treat it like it's the last festival I'm ever going to go to. And do it without the idea that I fail somehow if I don't win a prize.

Let the Games Begin

"That's Altman, you idiots!"
— Unnamed critic, to paparazzi oblivious to the direc-
tor of *M*A*S*H*, *Nashville*, *Short Cuts*, and the festi-
val's opening night feature, *Cookie's Fortune*

Although it may seem strange, the inaugural evening of each
Sundance Film Festival—to which attendees wear anything
from tuxedos to plaid shirts—is held not in Park City but in
Salt Lake City. This allows Sundance to accommodate the
large number of local dignitaries, filmmakers, organizers, and
press who want to catch a glimpse of Robert Redford, and to
let mainstream Utah see that nobody's going to bite. The
festival assumes a very neighborly attitude toward its mostly
Mormon neighbors—the opening gala film, for instance, is
always guaranteed to offend no one (except perhaps critics).
Among the films that have opened the festival over the years:
Nora Ephron's This Is My Life, *Kenneth Branagh's* A Mid-

winter's Tale, *the Gwyneth Paltrow vehicle* Sliding Doors, *and, in 1999, Robert Altman's* Cookie's Fortune.

◊ ◊ ◊

Robert Redford, at the opening night gala of the Sundance Film Festival, January 21, 1999, Abravanel Hall, Salt Lake City: We love the idea of the audiences here in the area participating in the process that we have. But finally, it's a celebration of the artist that we're about. This festival is for independent film and it's for and about you filmmakers. And it's you that we are here to celebrate. It's your courage, your stories, your vision, your unique passion and commitment. Not that those are exclusive categories, but in the business we're in, it's pretty tough to hold the line with those qualities. And we're in support of them.

So that's what we're here for, and the particular vision you have. That we're able to gather together once a year to celebrate is something we're happy to share with audiences here and elsewhere. So from around the world to here, we gather these artists together and celebrate their work, and the stories they tell are stories that for some people will be thrilling, for some people will be appalling, but they will never be dull—and that's the way we like it.

And those stories are there for you as a reflection of the world we live in. They're not stories you can see on television, not stories you're gonna read about in the papers. They're really unique stories, and their stories are our stories. They're not into answering. They're

into questioning. And their questions are our questions. So having said that, we welcome you once again. Glad you're here. And let me say, I know everybody gets into a big long roster of thanks for this, that, and the other thing, so I'm just going to say one thing about the filmmaker that we're celebrating tonight: when one thinks about the definition of independent film and what it means, in my mind there is no greater example of that than Robert Altman.

Since I had the pleasure of working with Bob many years ago on television, it's a particular pleasure of mine to welcome him here and celebrate his work. Beyond that, there's a kind of a line here at the festival, and behind that line is a hidden territory I'm very, very, very proud of, and that is the people who make this thing happen. What you see and experience is not easy to pull off. The number of films screening is 118, but there were a far greater number submitted: 840 dramatic films, 220 documentaries, 420 international entries, and [more than] 1,300 short films. Selecting them is not an easy task: Geoff Gilmore is wearing a bullet-proof vest back there. *[laughter]* But personally, I don't think the codirector of the festival, Nicole Guillemet, ever gets quite enough credit, and the staff she operates is mostly volunteer. So they're the unsung heroes of the festival, but they're ones I'd want to pay particular thanks to.

Geoffrey Gilmore, festival program director: Welcome to the beginning of the Sundance Film Festival. Bob has

Robert Redford, head of the Sundance Institute, speaking at the annual Filmmakers' Brunch at the start of the festival.

explained what the import and purpose of this festival is. We think we're making uproads. But we'll see what the experience of the next ten days is going to be.

Robert Altman, director, on the opening night presentation of *Cookie's Fortune*: We got offers from Cannes and other festivals wanting to premiere it. But this just felt right. This is the right atmosphere—a place where small films are nurtured. And for me this is a small film.

I'm just happy they still let me make movies. That's as much of a cause for celebration as anything else.

Cynthia Palumbo, mother, and Alison Palumbo, daughter, after the opening-night screening of *Cookie's Fortune*:

Cynthia: We're from Ogden and they have some films there; we're going to a premiere tomorrow night in Ogden and we have some tickets for Trolley Square—

Alison: And the Eccles in Park City.

Cynthia: It's like an hour's drive, but it hasn't been snowing much lately so it's not much of a hardship.

Alison: This is our second year. Actually, what we did was we bought student vouchers. They're cheaper—there's ten vouchers for fifty bucks—so we bought twenty this time. So any ticket that's available, you can trade for available tickets.

Cynthia: But we didn't get tickets for tonight ahead of time; we had to do the waiting list, so we were numbers fifty-three and fifty-four on the waiting list.

The movie? Oh, it was very wonderful. I love Robert Altman, and this was much different from what I've seen.

Alison: Yeah. It was great.

Buzz

"You create this early buzz that can be quite harmful. The buzz around *Kids* at Sundance [in 1995] created a negative stigma. So much so that everyone involved is still fighting to get away from it."

—Chloë Sevigny, star of *Kids*

"What's the last year been like? 'Dumbfounded,' 'blindsided,' and 'flabbergasted' are words that seem appropriate."

—Ally Sheedy, recounting the Sundance buzz off of *High Art*, which presaged her 1998 L.A. Film Critics Association's Best Actress Award

Over the years, the Sundance microscope has been ratcheted up to such a power that unless you're completely outside the industry, you have a pretty good idea going in about what's going on in terms of "buzz"; this includes which competition films are fated for pickup and distribution (if they haven't

Heather Donahue faces her gravest fears in *The Blair Witch Project*, a pseudodocumentary horror film that was the most highly anticipated Midnight section feature.

already been picked up prefestival, which has become more and more common).

The real excitement surrounds the newest films, ones that even distributors might not have had a chance to see before January, leading to two phenomena: the suspicion that deals on films are occasionally made before Sundance but are kept under wraps in order to generate the greatest amount of press, and a close-to-insane crush for tickets for the first screenings of these highly anticipated films.

As Sundance 1999 was poised to begin, certain films were aquiver with buzz, among them the documentaries Sex: The Annabel Chong Story, *a look at the porn star who set a world record by having sex with 251 men over a ten-hour*

period; American Pimp, *a self-explanatory film title by the Hughes Brothers* (Menace II Society, Dead Presidents); American Movie, *Chris Smith's account of some very low-budget filmmakers trying to produce a horror film; the nakedly candid cancer diary* Death: A Love Story; *and the formidable* American Masters *production* Hitchcock, Selznick and the End of Hollywood.

The most talked-about fiction features included the comedy Happy, Texas, *about a pair of escaped cons who elude detection down South by posing as gay beauty pageant promoters;* Three Seasons, *the October Films–produced Vietnamese drama by Tony Bui featuring indie veteran Harvey Keitel; and* Joe the King, *a sensitive drama about childhood by actor-turned-director Frank Whaley.*

And although it was not in competition, The Blair Witch Project, *an experiment in terror that was part of the festival's ''Park City at Midnight'' section, got greater word of mouth with every screening.*

At least one bona fide masterpiece, Kore-eda Hirokazu's After Life, *was in the noncompetitive and all-but-ignored World section, as were a raft of top-flight films: Emir Kusturica's* Black Cat, White Cat, *from Serbo-Croatia; the revelatory* Barrio *by Spain's Fernando Leon de Aranoa;* Run Lola Run *from Germany; and* Train of Life *from France, which is what every Holocaust comedy should be.*

<div align="center">◐ ◐ ◐</div>

Laura Kim, mPRm Public Relations, Los Angeles: I think this year's going to be a really slow sales year. I think people had a lot of disappointments last year;

most of the independent films that opened last year were disappointments. Actually, I think all the buyers should get together and hold hands and decide they're not going to buy a movie for more than one or two million dollars and save the rest for P and A [Prints and Advertising], so when the movie's released they can compete with all the other movies coming out.

Because when they spend all this money on the movies and then open them six months later, they're spending less and less on advertising and prints and things like that, and it's sitting more heavily on us— and *we* can't open a film; a film needs to open with *all* these parts in place. They need media buzz, they need television, they need all that stuff. So they should spend less at the beginning. Directors should feel that it's a privilege to get a theatrical release, not a right. And maybe it will dry up some of the dreck out there.

A lot of distributors are out to prove they have more money and make splashy buys. If they had any sense, or talked to their marketing people or went back to L.A. and thought about it, they wouldn't buy a lot of these movies. These movies need more support when they open. Because there are so many movies opening every week, these movies cannot compete.

Mark Ordesky, president, Fine Line Features, on acquiring documentaries: Obviously, Fine Line acquired *Hoop Dreams* out of this festival, one of the most successful documentaries of modern times. We distributed Barbara Kopple's *Wild Man Blues* last year, which I hope

will have a shot at an Oscar nomination. It's something we do, but we do it opportunistically. None of these companies—Fine Line included—have what I'd call a quota system. For example, we love foreign-language films and we're going to buy them, but you don't have a quota: if you see a good one, you go after it, and by and large you're going to see at least one a year or a couple a year. I'd like us to find one, two, three foreign language films a year, but you gotta find one you love, and you have to not get beat trying to get it. Not get beat by one of your competitors.

This year's documentaries? Interested, yes. But in terms of making a bid for one? Probably not.

How Bad Can *That* Be?

Eric Mendelsohn worked with Woody Allen's costume designer for many years (on such films as Husbands and Wives *and* Crimes and Misdemeanors) *before bringing his short film,* Through an Open Window, *starring Anne Meara, to Sundance in 1992. It later played at Cannes and the Museum of Modern Art. He returned to Sundance this year as director of the competition film* Judy Berlin.

Eric Mendelsohn: It's very nerve-racking. I'm showing a film that literally no one outside of five people has seen, I'm in the most emotionally vulnerable place I've ever been in, and at the same time I'm standing in a group of piranhas and Hollywood types.

At the same time, there's a part of me, a calm part

of me, sitting in the back of my brain crossing its legs and saying, ''You get to show your film. How bad can *that* be?''

Whatever happens, I'm pretty calm about it. I think it's the Xanax. I owe an enormous debt to the maker of that particular pharmaceutical.

Communications

> "One more thing: If you have a cellular phone, please, please, *pleeeease* turn it off!"
>
> —Programmer Rebecca Yeldham, to cheers, at an Egyptian Theater screening

> "They are in deep trouble. We're going to really crack down next year."
>
> —Melissa Kaffey, Park City's facilities and special events manager, regarding the perpetrators who glued fliers to the doors of municipal buildings

◊ ◊ ◊

Claire Terraciano, administrative director, New York's Film Forum: Last year at a sneak of *The Big Lebowski* at the Eccles, a friend was sitting next to this guy whose cell phone went off before the screening. And here he was saying, "I'm at *The Big Lebowski*. Where are you?" And the other guy apparently says, "Oh, I'm here too." So the first guy is like "No kidding? Stand up." And

all the while they're waving at each other across the theater, they continued their conversation on the telephone.

Michael Barker, Sony Pictures Classics: Communications are really so difficult, but I still always had this hatred of cell phones. But one year, Marcy Bloom and I were in Sundance early and one of the reasons we came early was to see *Walking and Talking*. So they were supposed to screen the film at ten P.M. on a Friday. Marcy and I go to a movie in the morning and Geoff Gilmore comes onstage and says there's a horrible snowstorm and the *Walking and Talking* screening isn't going to happen because the print can't get there.

I went to two more screenings where it was also announced that *Walking and Talking* would not happen. So I didn't think anything more about it. That night I went to dinner, and *Walking and Talking did* screen— three doors down from where I was having dinner! But I never knew the print showed up because the communications were so poor. The movie got sold, and not to us.

From that point on, I got a cell phone.

Esther Robinson, producer of *Home Page*: The other night I'm at a bar, the Club on Main Street, for an Independent Film Channel party. And it was a stressful day of screenings—you get to this point where you have to blow off steam. And you get into these slightly compromised positions where you're with important

people but—you've had some liquor! So I've had my liquor and I'm with this group of guys and everybody wants to hear about *Sex: The Annabel Chong Story*—it's all anybody is talking about.

So I started telling them the story about it, and, y'know, it's graphic, but it's really kind of funny that it's so graphic 'cause here you've got all these guys, they're kind of straitlaced—they're satellite guys, right?—so this is all very titillating. And here I am, The Girl, and I'm sort of, like, chatty, so I go into the story, waving my arms around, talking about this crazy movie where she's gang-banging 251 men.

And the poor guy from the satellite company has his cell phone on and somehow manages to hit "send." He was, like, so excited about the story that all of a sudden he hits "send," and the last person he called happened to be his wife. So she answers the phone and hears me talking about Annabel Chong.

The guy was so upset he had me call his wife myself to explain what was going on.

The Phenomenon of the Bladder; or, One of Those Vibrating Things

Mike Figgis, British director, premiering his *The Loss of Sexual Innocence*: The movie was thirty minutes late starting this morning because they'd forgotten the Hugo Boss tag—'cause this was a Hugo Boss–sponsored event or something. I hate it when you start a screening and everyone's antsy. It's the first screening of the day, so

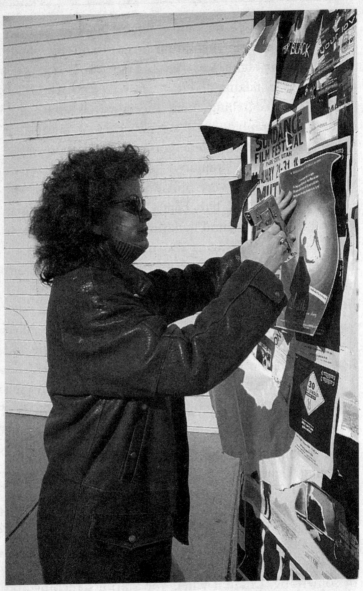

Director Michelle LeBrun spreading the word on her documentary, *Death: A Love Story*.

you don't really have an excuse for not being ready; nothing's run over yet. I said, "Look, I'll just make an announcement and thank them, just give me a piece of paper and I'll read it." But we had to wait while they put the logo on the beginning of the film.

I was angry being in that position because of a fucking Hugo Boss tag, and I assumed that the coincidence of a large part of the audience leaving was practical, not personal. It was a strange experience for me, because I love watching the film—any film—when it's at this stage, when it's first seen by an audience at festivals. They're always saying, "You want to go have dinner and come back for the Q & A?" And I always say, "No, it's very important for me to see how the film's playing."

The two things that really got to me today are the phenomenon of the bladder—how *do* you go to the film and three minutes into it realize you need to piss? How rude is that to your fellow viewers? I also practiced with the door at a certain point to see if it was really as noisy as it seems, and you *can* exit that cinema literally without making a noise if you just push the bar silently.

Then a very good friend of mine—an *ex*-friend—I saw take five or six mobile-phone calls during the screening, walking out of the theater and then coming back each time. He obviously has one of those vibrating things you can't hear, but he was talking as he came up the aisle.

I was so offended. I know it's a film festival and I know it's commerce. But if we've gotten to the stage

where at an intellectually credible film festival people can't even come without realizing they have to piss or turn their mobile phones off, I don't want to make films anymore.

The arrogance of it I just find stunning. I'm totally in favor of, y'know, "Life is short," and if you're not enjoying the film, leave. But I usually leave very quietly—look for a loud point in the movie and just kind of get up and ease out of the door. I'm horrified by the way people do it here. Come in with troughs of food, they talk, they leave, they fart. As somebody said, they obviously really think they're in their own living rooms.

But you know, it's [that way in] London, too. For a while I stopped going to the cinema because I thought I'd probably end up in a fight sooner or later. And probably *lose*, because these people are very aggressive! But you do get fed up: "Would you please just shut the fuck up?" And this is after you've asked four times. With a lot of films it simply wouldn't matter, 'cause they're such blockbuster, mindless films. But I am shocked to see it here, I have to say.

I'm not going to bad-mouth the festival; it's a lovely venue, it really is. And I thought the screening last night on the big screen at the Eccles was fantastic. Lovely response. I'm sure some people detested it. But that's cool; it's a tough film, and there's no rule that says you have to make a movie everybody likes. In fact there should be a rule that says you *shouldn't*, y'know?

But you're talking about having to make the reeducation of the audience a hip-enough thing. Almost like

you need the Black Panthers saying, "You don't fuck around with this; it's a delicate piece of expression, it's fragile, and if you can't tolerate that fragility we don't need you in the cinema—fuck off." I think you need some militant physical aggression, just publicly kick the shit out of somebody. Just say, "Look, I paid my eight bucks and you've ruined the film for me." To break that concentration, in a concert hall, theater, whatever, you enter into a contract with your performer—and the cinema's no different—to have a suspension-of-disbelief relationship with whoever, and if I want to do that, and you constantly break my concentration, I get really angry. And not just with my film. I know a lot of people are angry at this kind of sloppiness.

It's like that Lenny Bruce routine about Dean Martin or whoever it was doing a nightclub act and the mobsters in the front row keep talking, and finally Dean says, "Will you shut the fuck up?" and they do, because nobody's ever spoken to them like that.

If you lose a few fans on the way, well, they don't understand anyway.

Transetattion

Park City is—you have to face it—in the mountains, usually covered in snow, and incompatible with foot travel. During the festivals it's inhabited largely by New Yorkers who never drive and Los Angelenos who never stop, and a large contingent of people who feel they have a right to valet parking, whether there is valet parking or not.

This creates problems.

The festival runs a shuttle system that works in tandem with the free municipal buses. But of course, for a system to work, the people have to be cooperative.

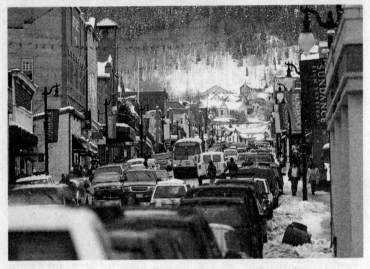

Main Street, Park City: 29 degrees Fahrenheit, 45 degrees incline.

❍ ❍ ❍

Sarah Eaton, publicist for October Films, New York:
It was hairy going down the mountain. It was so windy
it was scary. But you know what's really scary? That
so many people here, the New Yorkers at least, never
drive all year long—until they get *here*, and there's two
feet of snow!

**John Oblad, festival shuttle driver, as riders board his
bus:** I work for the charter company, Lewis Brothers.
The name's John Oblad of West Valley City, which is
west of Salt Lake. This is my first year. Most of the
people are nice. It was interesting; last Thursday, Friday,
it seemed like all the drivers were real polite—if I

needed to turn left out of the Yarrow, they'd wave me across. Saturday, Sunday, and Monday, they were trying to *hit* me! I don't know what changed. . . .

I'm one of three who does the theater loop; I just go to the theaters. One of the things that's confusing for the customers is that I don't stop at all in the city—

Woman, mounting steps of bus: Shadow Ridge, right?

Oblad: No.

Woman, leaning into bus: No Shadow Ridge?

Oblad: No. Catch a van over there.

Woman, poised at top of bus steps: But you go this way? Down Park? The 7-Eleven?

Oblad: No, I go to the Yarrow and the Library. That's as close as I get.

Woman, crestfallen: But you don't do any stops before that?

Oblad: I don't stop *anywhere*.

Woman, getting off bus: OK.

Oblad: That's the problem. And then when I don't stop there and people's waiting at the city stops, they go

crazy. The trouble with some of us stopping and the rest of us not is that they learn we'll stop *anywhere* and there's no organization to it at all. So you can't make these stops.

Travis Haywood, driver and travel coordinator: This? It's a challenge. I work for the army full time and coordinate a lot of exercises and movement and stuff like that, and something like this, with civilians and untrained people, it's *fun*.

I work for the National Guard full-time, yeah, I'm a communications signal chief, hold the rank of master sergeant. So I've got the Olympics to look forward to; I'm part of the work group for that. Last year I was deployed to Fort Lewis for an exercise, so I missed the festival last year. What makes it different from a military exercise is the turmoil, the not-knowing-what's-going-to-happen. The people here are magnificent. The first time I did it I wondered if they'd be obnoxious and abusive. So what I did, I got on the bus and cracked jokes and stuff, and absolutely no one was uptight when I did it.

I drove the van but I was coordinating, deconflicting, and if we had an accident I'd do the accident reports and stuff. We only had one accident, which of course was great. What I did was I had three radios and I taped them all together and then I hoped I knew which radio I was transmitting on. But I'd have cars towed and—usually the people who were doing the films, they'd park in the middle of the road. So I'd call the police and have 'em towed. That was kinda fun.

She Smiled at Me

Howie Moshkovitz, Denver-based film critic, on a certain international film representative: You know that she has a certain ranking, a ranked list, of film critics in her head at all times. And I know she always speaks to me the next-to-last day of any festival we both attend—never before. If it were a six-year-long film festival, she'd speak to me the next-to-last day.

But I saw her here, it must have been three or four years ago and the snow was just *dumping*. And I had a car. And all of a sudden—she smiled at me! "Howie! How aaaaaahhhhrrrrrre you?" She was with some French director, and I gave them both a ride. You know? I think, I *think* I moved up a day on her list from then on.

Matthew Braun, volunteer from Santa Monica, working the Main Street bus stop: Basically we get to pick our shifts. If you work indoors, you work like eight hours; if you work outdoors, you work only four and a half hours. So I chose this Sundance shuttle stop. So I don't mind the cold. I'm originally from Chicago; I'm out here in the cold, no problem.

The benefits are, where you work you can meet people—like *we're* meeting. The people are friendly, you get free lodging. You get to go to all the movies for free, but you're wait-listed, so it's more challenging to get in, but you get in. And the other thing is you get to go to all the parties for free and you get a list of the parties. So the benefits to me outweigh the cold.

For me, I'm thirty-one, six years out of film school, and I have a background in acting and in camera and my goal is to direct, to combine the two. And this is just a smorgasbord of young directors. I've done it before, and last year, standing out in the bus stop without really trying and just talking to people, I wound up with some fifty business cards over the course of the thing. Usually when you're out at the parties it doesn't happen.

So I made a lot of connections just hanging out and helping folks. When I'm not doing this I support myself as a camera assistant, keeping movies in focus in Los Angeles. It pays good money and it allows you to be next to the camera and learn about filmmaking firsthand from some of the most talented people in the industry. Like at the end of last fall I worked with Russell Carpenter, the guy who shot *Titanic*. When you see filmmaking at that level it's a wonderful thing. What we do at my level is a lot smaller, but it's neat to have a taste of that 'cause it lowers your anxiety and improves your skills.

Media

> "Janet Maslin called the film 'delicate' and 'familiar.' I'm so agitated I want to call her—maybe leave a nice message and have her call me back and THEN yell at her!"
> —Bingham Ray, copresident of October Films, representing *Three Seasons*

The press crush at Sundance has increased annually, from the few hard-core observers of years past to the hundreds who are now credentialed. There is a certain tier system— representatives of higher-profile publications get a better pass, while reporters from trade papers and dailies are often given an embargoed list of winners prior to the awards ceremony in order to make their deadlines, and media VIPs are given VIP treatment. Regardless of who you are, however, the press office staff—mostly volunteers—works very hard . . . and for its efforts is often treated like garbage by a press corps that many times can't cope with the stress.

❍ ❍ ❍

Derek Malcolm, critic emeritus, *The Guardian*: Well, this festival intrigues me because my paper's very anxious to know how the British films are doing in America. We're always totally surprised that you seem to like our films so much, because *we* don't like them half as much as the Americans sometimes. One of the films we really wanted to see how it was going to go down was Tim Roth's *The War Zone*, because none of us had seen it. So that's one reason, to see how we're doing in the States in the independent sector. The other reason [for coming] is to see if there's anything good from America.

Sundance has become very fashionable. The idea in Europe is that there are three major festivals in the world now: Sundance, Cannes, of course, and Toronto. I don't know if that's absolutely true, but that's the idea. I think Venice is still major. But Sundance is becoming very fashionable, and it's a delight to come here.

But it's a very tricky festival. In fact, I think it's one of the trickiest festivals I've ever been to. Getting around the town in the snow on the shuttle, not knowing quite where anything is—it does take you several days before you know if you're standing on your head with your ass in the air or what the hell's happening.

And then there's the problem with getting tickets. For some unknown reason the festival wouldn't give me a press pass, although I've been the film critic at

The Guardian for about thirty years; they ought to know me by now. I mean, I'm not being silly about it, but I think a press pass is my due, on the whole. I've got a sponsor's pass because the people who actually got me across here are Hugo Boss, who are the main sponsors of the festival—very nice people, treated me wonderfully, in fact much more luxuriously than I've ever been treated before, because *The Guardian*'s not quite as rich!

But I do feel the festival is right at the crossroads now, because it doesn't know whether to be a fully professional, important festival or to keep its old kind of amateur democratic status. But they've got to decide, because there are too many of us saying this is terribly difficult and I don't think it *should* be difficult for the press because if it is, it's bad luck on the filmmakers. So what I'm hoping is they'll really think hard about the press shows, have them in the same theater every day so that you go along to that theater and all the delegates and press can sit down in reasonable comfort without having to scramble for tickets, just get in and see the main films. That's what Cannes does, that's what Berlin does, that's what Venice does. I think it's the only real way to handle it.

Otherwise you get into this terrible muddle of getting tickets, flying around—the other big criticism I have of the festival, which I like and I think the people are very, very nice and I'm not criticizing them, but they really should start the shows on time. That is not professional. *Half an hour late?* Because if you do that, the next one along you miss, especially if you have to

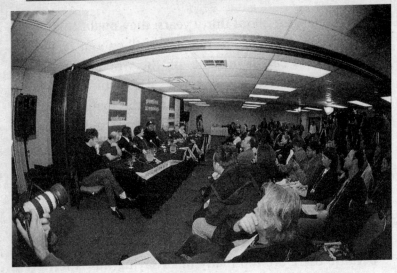

The makers of *Cookie's Fortune* hold court with the press.

take shuttles to the other end of town and you're not sure where you're going.

So I think it is at a crossroads. It's got to determine that it's going to be absolutely professional, because all the professionals are here and they deserve to be treated like professionals.

We're Probably on the B Level

Debbie Melnyk, Associated Press Television: I'm a freelancer and freelance for AP all the time. But since I'm Canadian, we also pick up stuff for Citytv in Toronto, Movie Television.

We send footage off to Associated Press Television

News in New York, around five tapes every couple of days. We shoot mostly celebs, 'cause it's a celebrity-driven entertainment show—beauty, ski shots. We shoot interviews with directors. Last year, we followed around Darren Aronofsky of *Pi*. We did a five-minute story on him. What luck! He won Best Director.

Butting heads? Yes, because the problem is, I need to get in to see films to do interviews with people, and the press screenings don't come quick enough for me to be able to do them because my interviews are usually the day after the actual premiere screening, the public screening. And for some reason the press screenings are a couple of days *after* the public screenings—which means if I don't go to the public screening, I don't know what to do; I don't have the questions to ask the director. I've asked the press office why the public screenings come *before* the press screenings and they didn't have an answer.

They've actually changed the system. When we first started, we couldn't go to the official screenings; we had to ask for tickets. Then we'd get in. Or we'd sneak in because we had to film the director introducing his film and then we'd get seats, which was the only way I'd get to see the film before the interview. Otherwise I'd have to go to my interview the following day and tell the director I really didn't know anything about his film, but I'd have to ask questions anyway based on the press notes.

Usually we spend our time screaming at the Nazi-type people they have in the doorways trying to stop

you from doing your job, basically. As my cameraman said, we have the opportunity to see hundreds of free screenings a year. We're not trying to *cheat* anyone, and we're always being put in the position where we feel someone thinks we're trying to cheat someone out of money, trying to put something over on the festival. No, we're just trying to do our jobs.

I try to set up interviews ahead of time before I get here. Because we're star-driven it's hard to contact people once you're here 'cause they're never in their offices or whatever.

And then again there's this A/B–level press hierarchy. If you're CNN and *Entertainment Tonight* and *Access Hollywood* you get everyone, and if you're Associated Press, well, we're probably on the B level. If you're a foreign outlet you're on the C level and they usually get no one! And nobody except the major networks gets Robert Redford—except the local affiliates in Salt Lake City!

Rod Dreher, film critic, *New York Post*: This is my first Sundance and I was not prepared for the mad rush for tickets on the first weekend. It's been incredibly frustrating. It got better as the week went on and the weekend crowds went away, but the handlers, the volunteers they have here are just clueless. I was trying to get into a press screening, to an American movie that doesn't have a distributor; I asked for the publicist, very politely, and the volunteer grabbed me by the shoulders, physically turned me around, gave me a little

Never a missed photo opportunity, as Park City's population of snow angels grows.

push, and said, "Back of the line." So of course, I ran back to the office and wrote a really nasty thing for the *Post* about that!

But I heard these stories from everybody. [Journalist] Harlan Jacobson witnessed how they refused to let people from the Shooting Gallery [a New York–based independent production group] into their own movie. Everybody's had these stories. If you have a relationship with the New York publicists, it gives you an advantage over everybody else, because if there are tickets there and they can get you in, they will do so. If I were here for the *Fort Lauderdale Sun-Sentinel*, I would probably be really frustrated.

Rick Caine, video journalist, Associated Press TV: This is the only film festival that's held in the middle of winter up among the ski resorts—by a guy who, coincidentally, owns a ski resort. How does one *buy* a mountain? I don't know.

Think of it in the grander scheme of things. We happen to be staying in Salt Lake City; the Olympic scandal is in full bloom right now, OK. The idea is the locals only scream so loud and so hard because their property values are going up even as the confidence in the Olympics goes down, and that's certainly true of this, too.

In the end it's all about money. Did you see *You've Got Mail?* Where Meg Ryan tries to stem the tide of the big invading book chain? Well, she does it via AOL, while drinking Starbucks coffee. You see what I mean? What's wrong with this picture is that a lot of the people who are running Sundance are driving around in these SUVs provided by Mercedes that cost more money than it did for some of these young kids to make their films—whether they're playing Sundance, Slamdance, Snowdance, Lapdance, or any of the assorted festivals that are here right now. It's kind of a weird thing—there's an irony there.

In spite of that, I think the festival's original purpose and intent has been realized—to change the face of American cinema. My parents used to say to me when I was a kid that the only movies worth seeing were foreign movies. Sundance has had a hand in changing that. We're starting to see a diversity of

films coming from different quarters. Of course, it used to be we were happy running and controlling the film industry worldwide; now we want to control the art houses, too.

Give Us This Day
Our Daily Bread

◊ ◊ ◊

Diane Lane, actress, *A Walk on the Moon*: I don't know Sundance; this is my first time out of the chute. I'm just connecting dots until they tell me I'm done.

I got my first bit of Sundance angst today, though, like, "Oh, won't you all just please go die somewhere?" I hiked up Main Street to get some kind of breakfast deal. I said, "Don't they have a diner? Is it only Starbucks? C'mon!" So somebody said, "Go to the Morning Ray, two doors north of the Egyptian."

So I go in there, and this girl hated me the minute I walked in; it didn't matter who I was. I wasn't exuding

"actress." I didn't have a stitch of makeup on; I was trying to drain my face of the morning puff from being at this altitude, so I thought, "Go out in the cold and hike!" And she'd just had enough—and I was the embodiment of everything she'd had enough of: *"I hate my job, therefore I hate you."* I could have let her ruin my day; I didn't because I'm just thinking it's got to be rough being the saddle for us, as a town. It's a bittersweet experience 'cause we just commandeer the place.

But she was young—young and really getting off on it, like she's an old pro and can't stand it. She must have been nineteen—and calling me "ma'am." Which made me want to clock her. Anyway, that was my morning whiff of resentment.

We're not the only dog-and-pony show that comes to town. There's this coming in, and that convention, and the Olympics. They're on the map whether we're here or not.

Christine Garcia, owner of Christine's Bake Shop, down the strip mall a piece from the Holiday Cinemas: I don't know what you people did for food before I was open, not in this part of town. How does the festival change life here? Traumatically. For my own business level, it's a marvelous increase—I do more in this ten days than I do in, let's say, the thirty days of June. So it's substantial.

There's long hours, of course. I increase my hours—normally I run seven to four, but for the festival we stay open till seven to accommodate through the early

dinner hour. The trend has become more and more for people to bring in, cater in, or cook, because even though we have a lot of restaurants, a lot of them are busy during the main hours.

The people who come here for the festival are wonderful, I love them. And the diversity is really great, and they're polite and nice. New Yorkers get a bad rap, but, you know, they're really *not* nasty. Part of the nastiness in New York, the rap all that gets—and I've lived there, so I know—is that you put that many people in close quarters, it's a little different. Put a New Yorker in the West where things are a little more wide-open, they lose that. People from Miami lose it. It's different environments. I've had this place six years and before that I had the same kind of business in Seattle, same type of thing. I came to ski, but I haven't. Too busy.

Lot of people live in town. There are ski bums. A lot of trust-fund babies. There are a lot of people who, for whatever reason, can live here and commute to work. And this is a big hub for Delta so there are a lot of Delta people, and all of these people are great. But coming from a small community and a big city like Seattle, it's interesting having this number of trust-fund babies—who are adults, but, y'know, cool. And they ski.

Takes the pressure off, though, doesn't it?

A publicist who insisted on anonymity, because God knows he needs to make a living: I was at Zoom the other night, you know, Redford's restaurant, and we

were sitting at the next table. Bernard Rose [director of the Beethoven film *Immortal Beloved*] had this dinner going on and more people kept coming in, and they were adding chairs but it was getting late. And at one point the manager came over to them and said, "I'm sorry, but we're closing soon and we won't be able to accommodate all these people." And Rose started to get loud. And nasty. So nasty that we were getting uncomfortable. And then he said something *really* nasty. So the manager called the cops.

Cheese It, the Cops!

If an Actor or Entertainer Is Out of Line, I Try to Arrest Them Just the Same as I Would Anyone Else

Sgt. Rick Ryan, Park City Police Department: I staff all the special events that take place in Park City: the arts festival, there's a pro golf tournament that takes place in July. And then smaller local events, Fourth of July, different things like that. I've been working the festivals for a little over thirteen years, so I've seen them almost from the beginning stages where we had three to four thousand people attending—which didn't have a lot of impact on us—to where we're probably at thirteen, fifteen thousand now, depending on the time of the week, since they have some overlap. So

we've had to try to learn the best way to facilitate matters with those numbers coming, as opposed to when it first started.

I quite enjoy it. You meet a lot of people, it's an event that a lot of people don't get the opportunity to work or be involved in, and it really helps us as far as managing events, since there are all these other events looking to come to Park City—especially the Olympics coming up. So professionally I've enjoyed it; personally I've enjoyed it.

From your professional perspective, isn't Park City at a bursting point?

RYAN: I don't think so. One of the things we've tried to do is work very closely with the Sundance Institute staff, trying to resolve any issues that come up. I think we work real well together.

We're kind of learning that what we have to do is educate festivalgoers about how to best use the transportation that the city and the festival offers to get the people where they want to go, and since we've been doing that—and we've *done* it because it's gotten so large—things have really just seemed to be clicking the way they should. It makes it certainly better for the citizens who live here and for the people visiting on their ski vacations. There have been new facilities—the Eccles Center, for instance—and it's taken a lot of the crowd off of Main Street, which was *really* not conducive to that number of people. There's still a lot, but there were times you could hardly move up there on Main Street.

We're proud to say we've never rented a car; we always take the shuttles.

RYAN: If people can just get that idea that it's the easiest and best way to get around—well, ridership on the buses this year was way up, and I saw a lot less congestion than I had in the past.

Is traffic the number one problem during Sundance?

RYAN: Traffic-related items. People behave themselves pretty well. We break up a party now and then, but not too often.

How does the police force deal with the, shall we say, sense of privilege that so many people seem to have coming into Park City?

RYAN: You mean their attitudes, or what they think their position is? We deal with that all the time, not just with the festival, because we have a lot of entertainers, a lot of big-business people who live here all the time. There's some big money here, and influential people—news people, television people. So we deal with them quite a bit and we try not to let that influence us in how we deal with them. We try to treat them the same as we would the visitor coming in to go skiing for the week.

Isn't it possible for a law-enforcement officer in Park City to go one of two ways—either to treat the celebrity with defer-ence, or to overreact in an effort not to seem deferential?

RYAN: Philosophically, yeah, that's right. But I haven't seen that as a problem with our people. I'm trying to think of any instance, particularly negatively, and I can't think of any.

I always try to be fair: if an actor or entertainer is out of line, I try to arrest them just the same as I would anyone else. We tow Roger Ebert's car just like we would anybody else's. We've towed Clint Eastwood's, we towed Willem Dafoe's; they park where they're not supposed to, we take them. We don't know whose they are, actually; it's kind of entertaining that way. They've all been very cordial about it. I've had dealings with people visiting, you tow their car and they'll come in and pay their fine and go, "That's a great deal: I get my car towed to a good, private, secured parking lot, get driven down to pick my car up and it costs me sixty-five dollars; in New York it would cost three hundred dollars for that kind of service." They all seem to respond pretty well to it. I think they understand.

Sgt. Sherm Farnsworth, Shift Supervisor, Park City Police Department: Towing a car is our last resort. People usually know they've parked in an area they're not supposed to. More times than not [we turn on our lights], they'll come out and move their car before you actually have to call a tow truck. I personally look forward to the film festival because you always can count on meeting a celebrity from having impounded their car. The guessing game is which celebrity this year is

going to have to come up [to the station] and pay an impound fee.

Sgt. Bruce Bennion: We impounded Clint Eastwood's car [several years ago] but still, in spite of that, he was a very pleasant person. He was very, very personable, a very nice person to visit with. He had his picture taken with us and seemed to be enjoying himself.

Civilians

> "Let me give you some advice. After 20 years [here], this is what I've learned: Stick with World Cinema. Because in World Cinema, films have already had to work their way through. And with everything else, *we're* the filter ourselves."
> —Festivalgoer at screening of the Cuban film *Life Is to Whistle*

Scene: Outside the Library, the first Sunday of Sundance, about 7 P.M, prior to the screening of *Tumbleweeds*. Dramatis personae: Marvin Halperin, San Francisco; Susan Saks, Pittsburgh.

Halperin: While you're being interviewed I'm going into the tent because I think it's kind of cold.

Saks: So? *You* be interviewed!

Halperin: Oh, no, you're the better one! I must say, though, that you've found the two best civilians in the world! (*Exit Marvin to warmth.*)

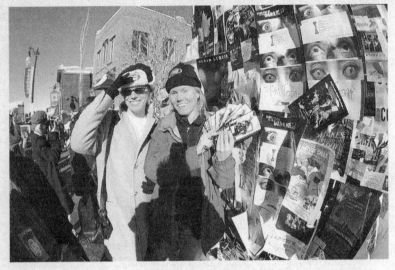

Ticketholders—or actually, subversive reps for a Slamdance film, *Dill Scallion*—infiltrating the ranks of the bona fide Sundance offerings.

Saks: Because we both go to five or six films each day. And about five or six festivals each year.

Usually I attend Telluride, Toronto, Mill Valley; Cleveland comes up in March. Marvin goes to San Francisco, Mill Valley, Telluride, Sundance. He's going to Seattle this year, and sometimes he does Santa Barbara. And we've both done Sarasota, which is disbanded; it's now in Acapulco.

But even though we're not professionally in the business, we treat our movie selections—well, there isn't such a thing as professionally, because it's all second-guessing. I don't do anything in the industry, but I do

now lecture about festivals, the joys of film festivals. I actually have a master's degree in library science, but haven't worked with that in years. I work in sales part-time.

I'm here early tonight because my previous film was canceled: *Dance of Dust*. They don't have the print and they don't think they're going to get it. They explained it's in an Indian film festival and wasn't shipped.

In Toronto they have separate press screenings and for the big films the actors and directors are introduced before the films, but they don't have Q & As like they do here. You can see them here on the street and in screenings, and even though there's a high percentage of press it's not paparazzi in terms of the celebrities wandering amongst us, so to speak. And their dress is very casual, much like this town.

I've been coming to Sundance eight or nine years. I believe it's fifteen. Since 1985. I started going to Telluride in 1985 and made so many friends there and they said you just have to start getting *Variety*, which I do, and *The Hollywood Reporter*, the weekly editions, and decided I needed more than one fix a year. It's not just the moviegoing; it's meeting all the people. And after this many years there isn't any screening—even here, as big as it is—that I don't see someone I know. But most of them are in the industry in some fashion. I know several festival programmers, several reporters, and several specialty acquisitions people by sight. They're usually too busy to talk to me.

London is one of my goals at some point; it's very

expensive. This is a very expensive festival: I paid for my room completely in August; I booked it when I left last year. The travel here isn't too bad compared to Telluride, where I have to take three planes and a seventy-five-mile bus ride. You can't fly to Utah directly from any airline in Pittsburgh 'cause we're a USAir hub, and USAir does not fly to Utah. So you do Delta or United from Pittsburgh. This time I flew Delta via Atlanta and then into Salt Lake; I'm going home via Cincinnati. This is the least troublesome festival in terms of travel—plus, I come on Wednesday to help avoid the stress, because I have to acclimate and have trouble with the altitude and dry air.

All of the festivals are very expensive. This used to be a bargain. Toronto still is, especially because of the American dollar. And the pass situation is not structured the same way. There, you can buy a fifty-pass, which means fifty movies, amounts to between seven and ten dollars a movie and that's it; the housing is less expensive, you don't have to take shuttles, which adds to the stress here. It wears me out. This year has been the best ever, and cabs are more available, depending on the weather.

The phoning situation is high stress. The quality of the movies is the only reason I keep coming back. Very high level of films, and since I'm not in the industry my primary focus is the World Cinema, because they're culling from the best of the festivals of the world, so they are outstanding. *Train of Life* is a number-one priority for me and I have a ticket for it. My favorite films

so far have been in that category—although *Three Seasons*, which is not in that category, really is World Cinema since it's Vietnamese. It's in the dramatic competition. But I loved *The Adopted Son*, which I saw this morning. It's an Academy Award entry film from Kyrgyzstan.

The phone thing? I did not get the patron's pass but I got an Eccles pass, but Eccles only shows Premieres and Dramatic Competition. So then everything else I have to buy separately. You have to phone in, which is torture. They give you two phone numbers, but I assume tens of thousands of people are dialing. I did get through the first day and they said the computers were down. If I had had to take a workday off to hear something like that . . .

Halperin, inside the tent: I know all these people, like Susan, strictly from film festivals, that's right.

I don't consciously try to meet people, celebrities, because I'm not in the business and I don't want to be in the business. But it happens. It happens in the sense that you're sitting next to someone or standing next to someone and they happen to be in the industry. I've met a lot of people from Panavision. And the wonderful director Robert Young, who did *Caught*, which was one of my favorite films. Come to think of it, *The Usual Suspects* was one of my favorite films. *Ruby in Paradise* I wasn't crazy about, but the film it split the prize with that year, 1993, *Public Access*, was Bryan Singer's first film; I thought it was great. When I saw it I thought,

"This director's really talented," and sure enough he came back with *The Usual Suspects*.

I first came in '91, and I think Sundance, logistically, is really tough; getting the tickets, the altitude, the snow, it's really tough. But I think the films here are better than any other film festival I go to—Telluride, San Francisco, Mill Valley, Santa Barbara—because of the Dramatic Competition and the Premieres. I think World Cinema is somewhat weak. American Spectrum is really spotty; it's either really good or really bad. But I prefer Dramatic Competition and Premieres. This is my favorite film festival for the films. But logistically it's very tough.

A couple of years ago I thought the festival was incredibly strong. *In the Company of Men, House of Yes*, I thought those were really quite wonderful. I also liked that year *Myth of Fingerprints*, although a lot of people didn't. I liked *Going All the Way* that year. Those are a couple that pop into my head. But there have been lots of highlights: Last year *Sliding Doors*, *The Spanish Prisoner*. It's hard off the top of my head, but each year I see some meaningful films. I love foreign films but have never been to a foreign festival.

People think I'm going to film festivals all the time, but I'm an attorney and split my time between San Francisco and Sacramento.

I Shouldn't Tell You That

Bob Tarpy, inside the theater: I've been here a lot, but my wife has been to thirteen consecutive Sundances.

My memory's not worth a damn but my wife has got a great memory.

Marilyn Tarpy: Yes, Marilyn, like Marilyn Monroe. We live in south Louisiana and we've always been involved with the arts, so we came to Park City with our three daughters around Easter, I guess, of 1986, and we went to Sundance one day. And bought a lot three weeks later. We ended up having a cottage there for twelve years.

In Sundance, which is forty miles from here, of course, there's a whole community of people who have cottages, some of them you would know, like [director] Pete Masterson. They rent 'em for you and it works great. So we've just been coming and we'd go to the June lab a lot with our daughters, and '87 was our first film festival. We just came skiing—we didn't know much about it. We saw *The Big Easy* and went to a luncheon they had. And we've been coming every year.

Now we have three daughters, two in the film business and the third one is a senior at UCLA and interns for [festival programmer] John Cooper and is really a mathematician, but she's majoring in Italian and she's helping set the database up. They have starting-up jobs, but good jobs.

It's been a big part of our lives. We go to Sundance so much. But it makes me excited that Redford, somebody like that who could have done anything with their time and their money, has such a vision. And he's so *on* that vision it's almost comical sometimes. And so I

think he's really done a lot. And the people who have worked for him for so many years, Geoff Gilmore, Michelle Satter, Nicole Guillemet, those people have worked so hard.

Of the films we've seen over the years, the ones that have really made an impression, well, I remember the last film on a Sunday night, seeing *Daughters of the Dust* and, being from the South, it made such an impression even after we'd seen seventeen films or whatever that week. And a film I loved, and it may be a little my age, but I do not understand why it did not do well, was *Box of Moonlight*. That's one of my favorite films. I'd followed Tom DiCillo since *Johnny Suede*.

Maybe I shouldn't tell you this, but I can remember when you could write the name of a film down on your ballot and give it a one through six. And so if we had a film we really liked, we'd say of others, "Oh, we really hated this film." I shouldn't tell you that. But I know a lot of people did that.

So they got smart and they got rid of the pencils and now you tear the ballot. So they cleaned up a lot of things about the organization. They built the Eccles Theater, which helped. So I think it's really organized. The crush of people makes for a problem; I think they have a facilities problem. But there's such an atmosphere! I think the people at Sundance don't want it to grow; they're trying to keep it small. I know they limit passes and that kind of thing.

One other thing: the deals always used to take place during the last three days of the festival. Now they're all

done before we get here. You can really feel it. Which is why we get the package A now instead of package B. [Ticket buyers who can't attend the entire festival can choose from the first or second half.]

Oh, one other thing that's kind of funny. Lipstick. We used to have this code where my daughters and I would refer to "lipstick."

"Oh, I need to borrow your *lipstick*" or "How's my *lipstick*?" And "lipstick" always meant there was somebody famous in the immediate vicinity. It's funny how you can find a way to use the word "lipstick" when you need to.

But now I've given away our secret code.

Transaction

> "Every buyer here is panicked at this point. There's really been nothing to buy, and everyone's under pressure to bring something home. But there'll be a breakout film. There always is."
>
> —Rachel Rosen, programmer with the San Francisco International Film Festival, just hours before the premiere of *Happy, Texas*

> "I am 32 now, and I wondered if this was a big exercise in worthlessness. But now that we are at this festival, I would say it is probably worth it. There is no certainty that I will make a dime on this movie."
>
> —Reed Paget, director of *Amerikan Passport*, a Slamdance documentary of global conflicts that took 10 years to film

Mark Ordesky, president of Fine Line Features, who buys *Tumbleweeds* midway through the festival: The

acquisition of *Tumbleweeds* is sort of a standard Sundance process. It's like a model.

Every year at Sundance, in the weeks and months before, everybody identifies the "buzz" films. They're convinced these are the buzz titles, and how they become buzz titles is a combination of agents hyping them; a genuine—perhaps—creative quality; and a bunch of people out on the networks of information trying to angle and pop different things—it's a completely corrupt process. Not necessarily a malicious process, but a corrupt process.

And inevitably, the rule of thumb is, no matter what the buzz titles are, something's going to come out of left field. This is acquisitions Mafia speak, but something's going to come out of left field and bang someone on the butt and God forbid you miss it—the whole idea is that your team has to be so tight and so together that when that left field thing comes, you're ready to move.

The classic examples, overall, are *Strictly Ballroom* and *Shine*—*Shine*, of course being the Sundance example. 'Cause that was one where everyone had read the script and passed, but people went to the screening here because it was an English-language film and it was available and no one had seen it—because it was way the hell down in Australia. No one expected to get blown out of their chairs at that screening. So that's the classic example of a left-field acquisition.

Tumbleweeds is more of how the majority of these things go down. It's a film where we'd read the script, met the filmmakers; we had a degree of expectation.

But the nature of the story and the cast was obviously of a small nature.

Going into the festival, we rank all the screenings as ones, twos, and threes [to allocate our resources]. A one is "multiple people at the first screening." A two is "one good person alone at the first screening," and a three is "somebody at a second screening." Apparently, all the other companies are doing some version of this same thing.

We put *Tumbleweeds* as a level-one screening. So we had two good people there—'cause we had hopes. And those two people really liked it, but they didn't feel it was something to jump on instantaneously. Therefore, it became a "second screener." We sent a senior vice president to the next screening to sort of up the ante— and the senior VP cried her eyes out. So suddenly, that made it sort of "Mark worthy."

Now, there's obviously a subjectivity to this business, because you would argue, "Well, if Rachel [Horovitz of the New York office] cried, other people must have cried, too, so why weren't there more big decision makers there?" Hard to say. Maybe it was *Happy, Texas* [purchased by Miramax] sort of sucking all that senior-executive energy in a different direction. It's hard to know how and why people prioritize. Be that as it may, based on Rachel's reaction and the description in the script, I went, along with our whole marketing team. I cried my eyes out also, as did the entire marketing team. As did the whole theater around me, it seemed.

I've cried at three acquisitions screenings in my en-

tire career, and that's saying a lot because I have a pretty sizable career. I cried at *Once Were Warriors* in Cannes. I cried at *Shine* here in Sundance three years ago, and I cried at *Tumbleweeds* two, three days ago. So when I cry, it's time to buy. Like "If it does not fit, you must acquit." Whatever.

I'm also known in the industry as an "easy read." Bob Weinstein of Miramax has the best poker face—you can't tell what the hell he's thinking, love it, hate it—but I'm an easy read. And I remember, I came out of that screening and I was "in mode."

Once You've Got Them in the Condo, They're Not Leaving. They Are *Not* Leaving the Condo

Ordesky: I was looking for the producer and I was gonna fucking find this producer. And a guy from another company, a smaller company who shall remain nameless, saw me. Obviously, he'd liked the film, too, and he took one look at me and said, "He's over there." And he was shaking his head. 'Cause he knew: once I'm on the case, I'm not gonna be denied. Once it's in my sights, the heat-seeking missile is gone.

So we found the producer, found the director, I just walked up to their lawyer and shook his hand and said, "We have a deal." I said, "Get the people, finish the Q & A; we're going to the condo and we're going to go right now." That's the cliché, sure, but it's a cliché because it *happens*.

In any case, they did their Q & A, we hustled them

into cars—I put one of us in each car to make sure no one would get a cell phone call from Harvey [Weinstein of Miramax] or Bingham [Ray of October] or Lindsay [Law of Fox 2000] that would suddenly compel them to peel off in another direction and not come to *us*. And while they're in the cars, everyone is instructed to work it, work it, work it on the way up to the condos, so there'd be no doubt.

We got to the condo and proceeded to make what turned into a three-hour marketing-publicity-distribution pitch—not on why should they give us the movie, but on why they should even let us negotiate for the movie—'cause this was an interesting case where no one else had put in a bid for this movie. Oftentimes, like on *Trick*, when the people came into the meeting on *Trick* they had two hard offers and a bunch of interest from other companies, so we were bidding very specifically against other people who'd already put down hard numbers; it was very easy to weigh and balance. That's the easier kind of negotiation.

In the case of *Tumbleweeds* we were having to bid against their anticipation and expectations. *Was Miramax going to call? Was Bingham?* Everyone had expressed interest, but this was the first, I think, senior decision maker they'd been put in front of, who was actually saying, ''I want it, I want it, I want it.'' So I'm sure they were thinking to themselves, ''Do we stay? Or do we put this guy off and see if we can stall it out long enough to get someone else involved so we can *really* get the bidding war going?''

Basically, they had to decide if they even wanted to stay. And I genuinely believe—I don't know what the lawyer was thinking—but I was looking at Gavin O'Connor and it was clear to me that Gavin and I were birds of a feather—except he's six feet plus and I'm not. This is a guy who's obviously very passionate, very emotional, probably is quick to anger and quick to feel strong feelings. I'm the same way. And I got the sense that *he* got the sense of "kindred spirits here." So they went into the other room to sort of decide if our pitch was compelling enough to start negotiating.

In the meantime, their cell phones are on during this whole thing. And they're ringing. Presumably there are other people calling, et cetera, et cetera. Everyone knows everyone in this business, so people must have known: "Shit, they're in a condo somewhere!" and it's the last thing you want to hear when you're a junior- or midlevel executive, that someone's gotten someone in a condo! Because if you're me or Harvey Weinstein or somebody like this, once you've got them in the condo, they're not leaving. They are *not* leaving the condo, it doesn't fucking matter. Why? Sheer force of will. Or money. Or some combination thereof. You just sit down—in the case of Gavin O'Connor, I literally just fell to my knees in front of him and said, "You are going to give me this picture."

When you want something really bad—listen, being clever, coy, and kind of strategic is for stuff when you're, I hate to use this expression, when you're bottom-feeding; when you like something, but only like it

within certain parameters. And then you're almost always going to get outbid. Sometimes you may get lucky and your bid is the high bid; you let it sit, you let people take the bid away—you *know* they're going to shop you, but there's an unspoken OK, 'cause you're not totally dying, you've expressed your enthusiasm, you've expressed a marketing plan, you've made a bid, you've proposed a back-end and they're going to have to shop you because you're not prepared to close them in the room.

If you're going to close them in the room it's going to involve a lot of money and/or a lot of passion, and if you're not prepared to do that, it's bullshit to bring someone into a room and say "Here's my lowball offer; you've got thirty minutes or fuck you." You *can* do it, but you'll have no credibility with sales agents or producers or lawyers or agents. You won't last. And I'm in this to last.

So they went into the other room, they came back and said, "OK, conceptually—*conceptually*—the film is yours, subject to closing. We buy the plan, we buy you, we buy the team, it's a match," et cetera. I said, "Well, you can turn the cell phones off then." And they said, "Well, nooooo; we'll turn the cell phones off when we've negotiated the advance."

The "deal" has a million parameters. But the most important one is the minimum guarantee or the advance. They say, "Once we agree on the advance, the cell phones go off and we're in exclusive negotiations. Until then we can't really put off everybody else." So

we begin the negotiation and as usual they're up here, I'm down here. Where are we going to get to?

There's the usual tension and stress because even though you might want the film badly, you have to make a return—cover the cost of the corporate overhead, make a return on investment, balance off the films that *don't* work, and so on. So from one to four we did the marketing pitch, from four to eightish we hammered and hammered on the minimum guarantee and eventually closed it. And *then* the cell phones went off and the real grind began. 'Cause once you close the minimum guarantee that's all great, but there's a million other terms, and from seven or eight at night until . . . was it eight or nine the next morning?

Jennifer Stott, executive director, publicity/promotions at Fine Line: It was nine A.M.

Ordesky: It was nine A.M. 'Cause it was eighteen hours, right?

Stott: No, it was twenty and a half.

Ordesky: Was it? Did you clock it?

Stott: Yes.

Ordesky: Well, from the minute the screening ended it was twenty and a half; from the time we started talking in the condo it was eighteen. Which is my personal

record. I've done these kind of negotiations, these in-the-condo, in-the-room, nobody-leaves-or-the-deal-is-off [things], on *Rumble in the Bronx, Shine, Trick,* and this was definitely the record.

Halftime Report:
Tumbleweeds

> "I wish Miramax would offer the Iraqis like a two-picture deal and just get it over with. It just seems so ridiculous compared with what's going on *HERE.* I mean, can't they come to some late-night conclusion?"
>
> —Eric Mendelsohn, director of *Judy Berlin*

By the sixth day, Gavin O'Connor had sold Tumbleweeds *to Fine Line Features.*

◊ ◊ ◊

O'Connor: It was amazing. I'm so grateful, man; these guys, they really embraced the film, before we even sat down. It was funny, 'cause after the screening I felt like I was being kidnapped. All of a sudden people were grabbing us, we all got into cars, and they had someone from Fine Line in all of our cars. Oh, we'd talked to other companies and they'd made offers, but we'd turned them down.

So we went back to Mark's condo, and he had the head of every department there. We had a bedroom in the back where we could have our little conferences. And the decision we made when we went into the bedroom—me, my brother, my manager Ken [Treusch], and Stephen Bier, our attorney—was, Let's not even talk about money. Let's see what their plan is for the film, how they feel about the film, what they think they can do with the film, because that was ultimately the most important thing.

And we came out and each one of them talked about the film, how they felt about it, how they saw it. They compared it to their marketing strategies on *The Sweet Hereafter* and *Shine*, films that I loved. And I saw something I didn't see with anybody else, which was a real passion and a commitment to the film. Looking in their eyes, I truly believed that this was something that they cared about.

And that was important because it was something we really cared about. It was almost like we had to give our child to someone to take care of now. And who do you want to take care of your child? I felt good with them; I don't know what it was.

Mark was great; I liked him a lot. There was no bullshit with him. Our discussions were about a December opening, sometime before January anyway, maybe November, in New York and L.A., but getting it out so it will be eligible for the Academy Awards. And also, he thinks he can hopefully get it on some reviewers' top-ten lists, things like that. He's hoping people will

like Janet's performance, and maybe even Kimberly Brown's. He talked about Anna Paquin in *The Piano* and what Miramax did with her, and he thinks Kimberly has a shot, too, and that's what I want to hear, 'cause I think those two deserve it.

And then hopefully if there's word of mouth the film will have legs and bring it along very slowly, which I like, as opposed to just throwing it out there and if it doesn't make it right away they pull it. They're not going to do that, which I like.

I'm just happy, man; I'm happy. I'm happy I can pay people back!

I got in a cab the other day and someone else was in the cab and said, "Hey, *Tumbleweeds!*" And I went, "Yeah." And the cabdriver just went, "Oh, my God, you directed that?" I thought, Hey, I'm getting it from a cabdriver, and that's usually the greatest source in the world.

I have to tell you, even before we sold the film I met so many great people, so many great filmmakers. When you go out and make a film, especially with the budget we had, you feel like you're in this bubble. And then you get here and start trading war stories and you realize they had some analogous experiences like we had. And the people have been really nice, and I've seen so many really cool movies. At the beginning anyway—Friday, Saturday, Sunday—I saw three a day. After that it's been difficult, because a lot of things have been happening. But it's been amazing and I've had the greatest time. I really have.

I think the defining moment of being here was up at Sundance. We were always told that if Mr. Redford comes to a film, it's up at Sundance, 'cause that's like his own screening room. And we were all hoping he was going to be there.

I'd met him a couple of days before. Geoff Gilmore introduced me to him. He knew the film. He was really nice. So we got up there and the woman said, "Mr. Redford may be here. But if he does come, he never shows up on time, and he doesn't stay for the Q & A. Just so you know; don't be insulted." I'm thinking, "If he comes and sees a frame of it, I'll be happy."

So he shows up. At the beginning of the movie—everybody saw where he was sitting, 'cause we were all watching him. And he stayed for the Q & A. He didn't ask any questions. But then after the Q & A he came over and said some really, really nice things. We spoke for probably ten or fifteen minutes. It was so cool, man; he was such a regular guy. He talked about the film, how much he liked it, Janet's performance. And the tone of the film, how what could have been a clichéd story was told in an original way. And Kimberly's performance. Then, of course, I had to introduce him to everybody: Angela, my brother, my cinematographer. Everyone was wonderful. But it was the defining moment, having him see my film.

Mark Ordesky: We're not going to put *Tumbleweeds* on a shelf between now and the 2000 Oscar race. We're

going to go back to Los Angeles after the festival and craft and fine-tune a marketing strategy. You watch— all very subtle, all part of a calculation. Festivals, column items, all kinds of stuff laid in very slowly, methodically. This film is definitely a little engine that could; that's certainly the way it got made. Fine Line, although it's one of the "major independents," has got a little-engine-that-could vibe, too. The movie will not sit dormant.

In the acquisition game, there are two parties always involved. There are the financiers of these independent films and there are the filmmakers themselves. So you could argue that if a financier finances a $3 million film that the director sweated blood to make, and a company buys the film for $7 million, the financier is very happy. The filmmaker will be more happy when the film is released, but a filmmaker always wants to make money because they get to make more films.

But filmmakers are interested in getting their films released *well*. That's what the priority is. Whenever you have any company that pursues a column game, by definition there's a risk that you might not make the cut. But even with companies like Fine Line, which are a little more boutique in terms of the size of their slates, the best insurance policy is still to make sure you're looking in the eye of the person who runs that company. Bingham, Harvey, Lindsay Law, myself, Russell Schwartz [of Gramercy]. And if you believe, really believe, that when the person says to you, "You're it,

you're the one, this is the film I'm going to build my spring around, my summer around," or my fall around in the case of *Tumbleweeds,* and if you believe it, theoretically it shouldn't matter that they have forty other films on their slate.

I had a meeting with Mark Illsley, the *Happy, Texas* guy, and he said, "What do I do if I have multiple bidders who are close, what do I do?" And I said, "It's not as complicated as you think. Use the look-in-the-eye test and you'll know. If you're any judge of character, you will know."

I've looked people in the eye and made the wrong choice, but I think people in this game are astute judges of character. I think we're all similar. But to get this far you have to be pretty good. And you'll still lose!

Gavin came to us originally. I'm sure he came to *everyone* originally. Fine Line produces about 50 percent of its slate and acquires 50 percent. You don't usually get two bites at the same apple. One famous story is that I passed on the script to *Shine*—everyone did—not once, but *twice*. I passed on it in Australia, and then on a subsequent draft eight months later in Los Angeles. But the key thing is I stayed in touch. I really did like the project, but there were certain things that scared me. I was very straightforward with Scott Hicks; I think he appreciated this, and I think James Scott, the producer, appreciated it. I called them when I heard they got financing, I called them in preproduction, during production, during post, I stayed in touch and I let them know—I have this line, it is a line, but

I mean it—I said, "Look, I'll be happy to overpay you when it's done."

As the logic goes, it's worth it to pay more then, because you're sure.

Halftime Report: *La Ciudad*

> "*La Ciudad?* Rigorously, aesthetically charming. Great score. Touching."
> —Rick Hemner, journalist, at bus stop in Park City

Halfway through the festival, La Ciudad *was still unsold. Undaunted, David Riker spoke inside the festival hospitality center at the Shadow Ridge Hotel.*

◊ ◊ ◊

Riker: At the church? Oh, man. We expected thirty people; we had over a hundred. Ninety-five percent were Mexican. Children, babies. Very, very exciting, very powerful. We had the screen up on the altar; the priest there at St. Mary's, Father Brussen, is very dedicated. He's not Hispanic but he speaks Spanish. After the film—it was late—people stayed to talk about who this film was for, who was it made for. A Mexican woman raised her hand and said, "Look, the film is

great, but we don't need to see it. We know this is our life. This is what we're living. We don't need to *see* it.''

And I was going to think about how to answer her, when hands started going up all over the church. And one after another of the immigrants said, ''*I* need to see this film.'' The first guy was sixty-something—beaten, his face just ravaged from a hard life—and he said he came here twenty years ago, worked in Texas as a ranch hand for three dollars a day. He'd been through everything. He's still a construction worker here. But he's now got this life together and he said the film helped him remember what he'd been through so that he could stay in touch with what the newer people were going through. Someone else said the theme about whether we should be united or divided struck a chord. So it was very exciting.

So it went well, and it was a welcome relief from the festival—the market. I tell you, this place, it's a market; it's not a festival. The festival organizers do a lot to try and make it possible for us to meet other filmmakers and talk, but they can't. . . . It's like a finger in a dyke, you see what I'm saying? I get a sense that there's not any time to meet any filmmakers *as film-makers* and talk about the substance of our work, our vision, whatever it is we're trying to do with film, be-cause everyone is for sale and everything is for sale. So the best you get is, ''How are things going?''—meaning, ''Have you been sold?'' Personally, I don't know how things are going.

We had one screening, and the response that I had

personally has been incredible. For the last four days wherever I've been going, people have been recognizing me and talking about the experience of the film. So it's been satisfying that way. Businesswise? Our situation is that almost all the distributors who are in the game have seen the film. All that we can hope for at this point is that the smaller distributors who have offered a distribution deal are still available. The bigger companies and the middle-sized companies are waiting. For something. *Something*. What is this "something" at Sundance? I don't know, unless it's more press. With a film like ours, if we have a significant number of respected film critics who'll make it clear that they'll support the film when it comes out, that helps.

Honestly, I feel, unlike in Toronto, here I feel really removed from the whole process, partly because we're not in competition. There's a sense that what's really important is these other films. Also because there's a lot of awareness of our film already.

For a filmmaker it's a terrible experience, from the beginning to the end, of trying to sell your work. It sucks. Undermining. And I know what's going to happen—or it already has happened—is that there's a negative impact on the work being produced itself. 'Cause filmmakers are leaving here saying, "Listen, look what sold. My film didn't sell. Look what *did* sell! I've got to change my whole approach so that in Sundance 2001 I'll have a film that looks like *that*."

Rick Caine, AP video journalist, pulling up a chair:
Sundance is like minor-league baseball. It provides the
grooming for young filmmakers to integrate into the
studio system. And in minor-league baseball, from what
I understand about it, it's not just a question of how
good is your batting average, and how well can you
play the field; it's also what kind of a team player are
you, you know what I'm saying? That's what they want
to suss out in the minor leagues. Everybody has certain
abilities in professional baseball. Every director who
comes to Sundance has at least a certain vision, or eye,
or call it what you want to call it. . . .

Riker: Your argument was very good up to there.
 I don't want to sound like I'm miserable, but my
job is to sell the film. But what's difficult is you have
no control. For five, six years you work on a film. And
even though it's an uphill battle and it seems impossi-
ble, you know if you just work hard and push you're
going to get there. But when it comes to distributors
it's not the same thing. You can push all you want. . . .

Halftime Report: *Home Page*

> "You have to try to maintain your center, remain Zen about everything, you know what I mean? You can't freak out about this reviewer or that distributor or get swept up in the anxiety of Sundance. You have to try and enjoy yourself."
>
> —Director Gregg Araki, bringing his fifth consecutive film
> *(Splendor)* to Sundance

Early in the week, Doug Block, *director of* Home Page, *talked amid a hungry crowd at a PBS-sponsored luncheon.*

◊ ◊ ◊

Block: How's it going? Well, it's going. We're going in very handicapped. With the additional handicap, to my deep chagrin—I mean, we could have overcome a lot of those things, but one handicap which has really been a bugaboo is the catalog description, which is factually inaccurate, filled with at least ten misstatements in the

ten short paragraphs. The writer projected her own opinions about the Internet on my film, really pejorative stuff about the Internet. Also, she made it sound really *boring*. It was so misleading that we had to counter it by hiring a publicist, which we weren't in a position to do originally, although Kahn and Jacobs liked the film so much they dropped their price considerably. But the catalog, it's like, "If you disliked the film this much, why did you pick it?"

And it was the one description in the catalog that didn't have one positive thing to say about the film. So I mentioned it to Geoff Gilmore—not from anger, although God knows I was upset—just saying, "I'm not going to let it ruin the thing for me, if nothing can be done, but if something *can* be done, can it be rewritten? I can't believe you would pick a film for the festival that was described this way in the catalog."

He looked at it and said, "You're right—we do a lot of these things and somehow it slipped by us, these things seem to happen once a year and guess what? It was you this year." So they did fix it in time for the big catalog—it's not a lot better but it's somewhat better—but everybody's carrying this version that went out to distributors and the press, the slim version and it's like . . . that's hard.

Serendipitous Things

Block: But I'm having a great time. What we did was rent a condo, a two-bedroom condo with two pullout

sofa beds, a fireplace, an outdoor Jacuzzi. One night, we even sat down and had dinner. We were so busy, I hadn't eaten. We're on the run grabbing at stuff; the plane was late and that started it. We had dinner after a screening, a bottle of tequila; six of us went out to the hot tub, peeled off our clothes, drank tequila, jumped in the snow banks, went back in the hot tub—had a great time. Got no sleep. It was just fun to have—I was looking forward to spending some quality time with Justin; that has been a real trip, he's just fun to be around.

And wonderful things, serendipitous things, have happened. A friend of mine from Israel is here. She has a girlfriend who didn't have a place to stay—she'd just flown twenty-six hours to get here; she's just sleep-walking—but, again serendipitously, the Star Hotel where my friend stays is a half a block from me. I went there, I pull her out. I was going to go to a party but I said, "You know? I just want to talk to somebody, get grounded again," and even after twenty-six hours she was too exhausted to sleep so we wound up talking all night long. She had no place to sleep, so I thought, I'll let her sleep in my bed. I figured she'd be asleep, I could sleep afterwards. It was my good deed, right? And you know, she's like this gorgeous Israeli actress, too. And she fell asleep and I was so revved up, the festival, the talking, and I was actually thinking through my festival experience, what I wanted, and the reality of it that I was here and doing this stuff, it all sunk in and the combination of having this beautiful young lady

sleeping on the side of the bed there and just being here—I couldn't sleep!

It was so weird. I'm lying there for hours with all these ideas running through my head. She gets up to pee at four and of course she's on Israel time so we just talked in bed for three more hours. About everything. I hadn't had one of those talks in years and years. And to me, that's what the Sundance festival is.

I told my wife. And I told the girl, "You can't sleep in my bed anymore." You know? I have to get to *sleep*. She has a boyfriend she's living with; I have a wife of seventeen years, and "You're not sleeping in my bed anymore. I need to get sleep. But it's been wonderful."

Why is she here? She doesn't know. She's stuck in her career, her friend had talked up Sundance, and she wanted to change her life. I so admire somebody impulsively coming here, not knowing where they're going to stay. I thought, "This is great; this is what life's about." The festival's great, but that sort of puts it in perspective. That's the kind of thing that's been really gratifying. Sitting with Barbara Sonnenborn on the way out here; she made *Regret to Inform*, which I hear is amazing. The filmmaker luncheon with Redford. To meet these other filmmakers—we all work for years in isolation for years and years and years. Barbara had another seven-year tale of making her film. They live and die with their films. When we talk about distribution, our talks among ourselves is very realistic. We know Miramax isn't beating down our door; we know

even Artisan isn't beating down our door. Which doesn't mean that they *won't*.

I actually heard from Jeff Lipsky that a lot of distributors are B-ticketing us, that they've heard about the film, but they're coming the second half—that the "buzz" films are pounced on the first half and apparently we'll get more consideration the second. We're doing a lot of postcarding. I decided the second day that the way to build word of mouth among audiences was to go to the documentaries where people are waiting in lines—these are the audiences—and I came with a thousand postcards. I walk from one end of the line to the other. Tell them I'm the filmmaker, tell them about the film, and tell them, "Come see the film, interact with the filmmaker and the people in it, become part of this big experiment."

So I hope it will build to something by the end of the week.

Network

> "Will work for distribution."
> —Sandwich sign proffered by Kaleo Quenzer, *The Big Muddy*

> "Sometimes, it opens doors."
> —Michael J. Moore, director of *The Legacy: Murder & Media, Politics & Prisons*, on being mistaken for the *other* documentary filmmaking Michael Moore (*Roger & Me*)

T. Patrick Carroll, Manhattan actor, aboard a Sundance festival shuttle bus: I just came out to get a feel. I'm a writer as well and thought it would be a nice place to get together with a bunch of people who are in the industry, get to know different people, different aspects. What better place to do it? Just a side of how the whole independent market works.

Actually, I get the feeling that everybody's here for

the films and *not* the business sometimes. I really got that feeling last night—I saw *Serial Lover* last night, the most original movie I've ever seen—and I went to the shorts program today and saw a bunch of people from all over the place that I wouldn't see otherwise unless I came here. So it was good for me. I haven't been in the business that long, but it helps to see different kinds of movies. And it's good to see people expressing themselves.

Plus, I'm really overwhelmed by how nice all the people are, the people in Park City and how, like, being from New York, I'm used to having people screaming and yelling all the time: "Get out of the way!" And the first encounter I had was with this guy Elvin who drove me out here. He was just the nicest guy, gave me tips on where to go, gave me some passes to go here and there. No lines yet. Maybe I've been lucky.

Sort of Plant the Seeds

Steve Barnett, Denise Di Novi Pictures: We have a deal with Warner Bros. and have some movies coming out—*Message in a Bottle*, February 12, hopefully going to be a huge movie. I'm here basically to scout new talent just like the rest of the development people. Individual talent. I'm not in acquisitions. There are a lot of those guys here, obviously, but I'm here to scout new talent, find out who's going to be the next Paul Thomas Anderson or Bryan Singer.

This festival I've been encouraged. I've been im-

pressed with a lot of the debut filmmakers; I thought Audrey Wells [*Guinevere*] did a great job with her movie. I thought *Happy, Texas* lived up to my expectations. And I'm very excited about *Run Lola Run*.

The idea is just to get into their world a little bit, expose our company and what we're all about to them, sort of plant the seeds. Most of these guys are going to have agents by next week, if they don't already, and so you just go from there. I don't sell clients. An agent's job is primarily to sell his clients—to get him on our projects. We work with the agents to get these talented people on our projects. Denise was partnered up with Tim Burton for a long time; she did that movie *Heathers* and I think she's more open than most producers in Hollywood to working with first-time talent. Definitely. In fact we have some emerging filmmakers on a couple of our studio projects right now.

Adrienne Gruben, producer of *Treasure Island*: We went back and forth for a long time about whether or not we should even come to Sundance. Our film is experimental. It's not a feel-good film, and we do expect walkouts. Sundance really isn't the place for that kind of film. Not anymore.

It Might Have Slipped By Without Being Noticed

Robert Panzarella, Texas physician and self-financed filmmaker, along with David Pierce, Cory Larson and Susan George of the film *Texas Day-*

break (a.k.a. *Joey Goes to Jail*), which they were showing to interested parties in their Park City condo:

Robert Panzarella: I've been writing screenplays for years, acted in several films, never really got anywhere with my screenplays and I said, "Well, let's see if we can make a low-budget independent film and break in that way." I was actually here at Sundance in '86 and '87 when it was still the U.S. Film Festival, and I got all this inspiration from that. I said, "If I ever come back it's going to be with my own film."

So our goal last May when we shot was to have this ready for Sundance. We submitted it, didn't get in; submitted it to Slamdance, didn't get in. So me and David go skiing every year and said, "Well, let's take our ski trip to Sundance this year, check it out and see what's going on." So I brought a copy of the film but didn't bring any posters or publicity materials. Once David saw all the posters hanging up, he said, "C'mon, we gotta get somebody to see this film." So we got somebody to fax us a picture and some publicity stills; we put it on paper and took it from there.

David Pierce: We're from Humble, which is right next to Houston.

Susan George: It's pronounced 'Umble.

Cory Larson: That's because we're so humble.

Panzarella: No, there's no feedback at all from the Sundance selection committee. They didn't even tell me how many films were submitted. Whereas Slamdance, they were a lot more humorous and offbeat. The letter said, "We had seventeen hundred applications for fourteen spots, so the odds are tremendous against you; you could have submitted *Citizen Kane* and it might have slipped by without being noticed with those kinds of odds."

Larson: Sounds like Sundance watched fifteen minutes of it.

Panzarella: This was kind of our first step. We also submitted it to the South by Southwest festival in Austin. We'll see how it goes after that, and probably go to the film festival market in New York. Try to sell it there.

A Couple of Publicity Chicks Sittin' Around Talking

> "I don't ski, and I came so unprepared clotheswise, you know, completely sort of Euro-trash clothing, high-heeled shoes—feather boas! I realized very quickly I'd kind of forgotten it's all boots and sweaters."
> —Helen Mirren, actress, *The Passion of Ayn Rand*

Laura Kim and Liz Berger, of mPRm Public Relations, Los Angeles, taking temporary refuge in a writer's condo.

Laura Kim: Remember *Spitfire Grill?* The film that wasn't selling in 1996? It was, they had an offer. I was actually typing up a release for a different buyer when they said, "Whoa! Hold that!" They were very close to signing with somebody. I think Trimark took them to court because they thought *they* had an agreement.

I was working on that movie and I was dumbfounded. And actually kind of mad. I can't tell you why exactly, but that's the kind of movie that feels like a

studio movie—it might just as easily have been made by Castle Rock for $10 million or whatever. But it also shows you that sometimes there isn't any justice, because a really great visionary film would never be bought for $10 million. But again—

Liz Berger: It didn't even break even—

Kim: But that price was for world, so when you divide up all the territories, it's not as outlandish as $10 million just for American. So it probably gets exaggerated.

Berger: Yeah, people think $10 million domestic—

Kim: But it's $10 million for video, home video, television ancillary and cable and all that. I'm not sure. Last year Miramax bought an Australian film called *The Castle* for what, $4 million? $6 million?

Berger: It's coming out the first quarter of this year.

Kim: Yeah, it's on their calendar. But they're also—they have the best taste, they're the ones who made independent film something that people started looking at. Of course, they're getting more and more accessible, because even the great independent film, even if it's extraordinary, if it doesn't have a star in it or some kind of hook—those things make it studio-oriented or kind of studio-minded. Anyone's hard-

pressed to get bought these days. And forget about documentaries. See if anyone's buying them. Thank God Sony Pictures Classics is still around getting these movies out, or Artistic License or Seventh Art, because the Miramaxes and the Gramercys, they're not doing docs. They're hardly even looking at them. Foreign films and documentaries are kind of a dying breed because there's so much American independent dreck out there.

Berger: There have been a few successful foreign films this year.

Kim: But you know how many great ones don't get bought? What I'm trying to do is get a lot of people to think about it. Any of the people who are trying to lift the movies or trying to open up the audience for these movies, we're all going to kill ourselves, and we can't really protest when they don't really perform at the box office, which makes distributors not want to pick these kind of movies up unless they're surefire.

We need to cultivate an audience. There's only so much we can do, you can do, the distributors can do. The theater owners, why would they show these movies? They have no obligation to lose money. The audiences in these little towns, nobody goes. I think the Independent Film Channel, the Sundance Channel, they're going to help. PBS, too, because in Middle America these movies don't see the light of day. Even

the big independent movies aren't seeing the light of day in a lot of these cities.

Independent Film's 15 Minutes

Kim: The corporate culture invades Sundance 'cause they think it's cool and they know they're in a hub of press and photography. You come up here now, well, we used to have parties for movies with money to spend. But now you have Gap parties and Motorola parties and Absolut Vodka parties, Hugo Boss parties. What are these? At least the parties used to have something to do with the movies. Now it's "Absolut Vodka is happy to present . . ." To have separate parties for consumer products? Very bizarre. And then you have different people being outfitted in clothes by different designers, to come up here so they could be seen in them. Tommy Hilfiger—

Berger: J. P. Tod—

Kim: Yeah, J.P. Tod. These are like four-hundred-dollar loafers! They just want cool people to be seen in their stuff. Whatever.

Berger: We make restaurant reservations months in advance. Every night, three different reservations under three different names. 'Cause the restaurants compare. And if you have three Pogachevskys, they cancel them, 'cause they know you can't be in all

A couple of publicity-seeking representatives of the Canadian film *Beefcake*, laughing pneumonia-friendly conditions in the face.

three at the same time. So we have one under Poga-chevsky, one under Lawson, one under Murphy, every night.

But we're very good; we always cancel if we're not going to make it.

Kim: It works both ways, though. A couple of years ago, we had arranged this really large dinner for forty people for this movie called *Big Night*, which was di-rected by Stanley Tucci and Campbell Scott. But their screening got delayed 'cause this woman had a seizure of some sort—they had to stop the film, they helicop-tered her out, or got an ambulance or whatever—so the movie was half an hour late. So we called Grappa,

I think Michael Lawson called them, and said, "We're going to be late! Don't give up the table!" A party for forty, and it's the cast and the festival people and the jury.

Berger: And a whole special menu had been created.

Kim: It was perfect for the movie—Grappa, which is Italian, fits *Big Night;* that's why we chose it. So at the end of the movie Michael Lawson and Mark Pogachevsky are running out ahead of the party and they get to Grappa and the woman who answers the phone never told the manager that we called to say we were running late. The manager gave up all our tables for forty people, sat all these other people down. By the time Stanley Tucci and all these people got there, there was no place for them to sit.

So Mark and Michael ran out on the street ahead of the party checking every restaurant: "Can you seat forty?! Can you seat forty?!" And they ended up at a minimall in some Tex-Mex restaurant.

Eventually, Grappa recognized that they were wrong, they realized someone had called, they gave us a lot of gift certificates and apologized and everything. They were great.

But as difficult as it all is and as cumbersome and as mismanaged or inconvenient or late or whatever it is, this is the best possible thing that could happen to independent film. Because Sundance is kind of like independent film's fifteen minutes. The rest of the year

nobody knows, nobody cares. And here, even if all the agents and the Hollywood machinery are descending on us and making it inconvenient, if they *weren't* it would be an even *bigger* problem.

Volunteers of America

> "Our job's to make sure the hotel's all secure, no violence and stuff like that.
>
> "No, there hasn't been any violence since I worked here."
>
> —Eric, security guard, Shadow Ridge Hotel

◊ ◊ ◊

Janet Sprissler, Los Angeles, working the Library: Why am I here? Because I'm an actress and I wanted to meet more people in the independent film market. Actually, because I've worked here at this venue I get to meet everyone who comes through the door and it's the same people coming out to vote, so I've made a lot of friends, actually, in just four short days. People in the industry, entertainment lawyers, actors, directors, and casting people.

The biggest hassle? Rude people. A lot of people come in and they just feel they should get in because they have a name or have a title and they've told us,

"You can't let them in." Or people just like shove you aside. Really. I've had people *shove* me aside. Then you have to get a manager; there's nothing you can do as a volunteer. The managers deal with it. They have the people leave. Or, if it's right they should come in they let them in.

My last day is tomorrow.

Bob Giovannelli, a.k.a. Volunteer Bob: Supposedly, Geoff Gilmore was coming in with somebody to the Egyptian, and the volunteer was doing his job, didn't recognize Geoff Gilmore or didn't recognize the other person and said, "No, there are only a few seats left; we need a certain kind of pass." And Geoff Gilmore got upset.

David D'Arcy, correspondent for National Public Radio: I was there. It's not that interesting. It was the screening of *The Blair Witch Project*. I had a hard ticket and this buyer from Sony, who I didn't know, had a hard ticket. I was the last person on the waiting-list line and they were letting in every asshole in the world, so I said, "I can't believe you're not going to let me in to this thing." And this guy from Sony said, "I have to see this film—I'm a buyer; it's my job." The volunteer was a jerk and I'll tell you why he's a jerk: He should have gone in and found the programmers and said, "Should we let these guys in?" And not just lay a trip on us. He was also acting like an asshole. He's a fairly tall guy; by theater-employee

standards, he's fairly tall. But Gilmore got pissed because he didn't consult them and then he chewed the guy out.

◗ ◗ ◗

Ann Russell of New York, working the press screening room at the Eccles Center: I was here and two guys walked by discussing a New York law firm—and when I'm not doing theater work, I temp as a legal secretary. So I know all the law firms in New York. And not only that, the guy I had a crush on in high school is a partner in one of these very prominent firms that they're discussing. So I say, "Do you know . . ." and they say, "Of course we know . . ." So P.S., of course, the next show that I produced I wrote to this high school classmate and it's been—I'm not afraid to tell you—thirty years, no contact. I get back this sweet letter: "Of course I remember you, we played in this play, we did this, we did that." And he didn't come to my show, but what the heck.

I produce, direct, and stage manage, and we're doing a very cute play which is Shakespeare set to music—which could potentially be awful but the music is so good. It's by a gifted composer named Dan Shamir, at Manhattan Playhouse, West Forty-ninth, and I'm also directing a very funny sex comedy called "It's Like Mamet, Dammit," by a young California playwright, and that's at the Theater Studio.

All I know is we're told not to let in anyone under seventeen to *Annabel Chong*. This is a *school*, after all.

Lisa Schwarzbaum, Entertainment Weekly critic, on the *American Pimp* screening: What was fascinating was that the top press, the top acquisitions guys, the big guns, they were all crowding in and they had the wrong projector so they had to move theaters. The theater holds a hundred and eighty people tops; the lines—if you had a ticket—went down the hall. It was sold out, double sold out, triple sold out. People were rioting and pushing and shoving. They were just flipping out. David Denby was there; Kenny [Turan] was in full dudgeon. Everybody was trying to get in. The miserable volunteers—who don't need this mishagosh from people from New York—were screaming at the people milling around, "Move back! Step back! I don't make any money at this!"

General Weirdness

> "Before I answer any questions, though, I just have to show you guys my flute."
> —Ken Kesey, following a screening of *The Source*, a documentary about the Beat Generation

He's Sort of Living in Our House

Eric Mendelsohn, director of *Judy Berlin*, Edie Falco, who plays "Judy Berlin," and Aaron Harnick, who *doesn't* play "Judy Berlin":

Eric Mendelsohn: We are so tired because we've been smoking crack.

Edie Falco: We were up very, very late, entertaining all kinds of people.

Mendelsohn: All sorts of people. People who are interested in the film for distribution, people who are interested in what I'm doing next, and people who want

to interview us. There seem to be a lot of caterers in the mix.

Aaron Harnick: We have a *Judy Berlin* groupie—

Mendelsohn: Yes, we have a *Judy Berlin* groupie—

Falco: He's sort of living in our house, but nobody really knows him—

Mendelsohn: We knew something was wrong when we saw him hiding the key in the different place.

Falco: He seems harmless enough, but nobody speaks to him really, nobody knows him, and he kind of sits there and watches us—

Mendelsohn: It's somewhere between *All About Eve* and *Single White Female*. He was waiting for us after a screening, very charming, said he'd love to make a movie, learn more about movies, and the next thing we knew, he was wielding a knife in our Jacuzzi. . . .

Falco: Everybody thought he was someone else's friend—

Mendelsohn: Nobody invited him—

Falco: Finally we all sort of said, "No, I don't know him either!"

Mendelsohn: He's like a drifter. A High Plains Drifter.

An Upside Possibility

Diane Lane, actress (*A Walk on the Moon*), giving an interview in a Yarrow Hotel corridor, while John Bernstein, Atlanta-based photographer/journalist, limps around:

John Bernstein: I slipped on the pavement—it wasn't even ice, just uneven pavement, so I landed on my knee-cap. So I won't even be able to go skiing tomorrow.

Diane Lane: Maybe you're being spared falling down the mountain and being paralyzed for life. So there's an upside possibility.

Unknown journalist: Amy Wallace of the *Los Angeles Times* is walking around with one of those flexible casts on, too. She hurt herself skiing. It seems like everybody's sick, crippled, or hungry.

Lane: Maybe we'll get Legionnaires' Disease, too. Oh, wait a minute. Turn around—

Another unnamed journalist, appearing on crutches: Hi, everybody.

Lane: This is, like, right on cue!

Bernstein: What is this, the Christmas pageant?

◊ ◊ ◊

Shortly after a Tuesday-evening screening of American Movie *began, pieces from the theater's ventilation system broke loose in the back of the Holiday Village Cinema I auditorium and fell on audience members, injuring three. Two were treated at the scene and returned to watch the rest of the film, which was continually plagued by sound problems. At one point the film broke and melted on-screen. The film ultimately finished, whereupon it received a standing ovation from the surviving audience members.*

They're Incredibly Vague

Comments at the Sundance Film Festival/BMG Music Studio concert Saturday at the Elk's Lodge:

Lisa Loeb, chastising talkative audience members during her set: It's all right. I'm going to talk at your movie.

Duncan Sheik, soliciting while performing his songs: They're incredibly vague and they are about the human condition. So you could put them in any movie at any time!

I've Seen You Somewhere

Heather Matarazzo, 15-year-old actress (*Welcome to the Dollhouse, Getting to Know You*): I met Glenn Close

yesterday. Remember the first time we talked, I told you I wished I could work with Glenn Close or Jodie Foster? And I met Glenn Close yesterday. I was saying all day, "I have a feeling I'm going to see her today and meet her." And there she was, after my last interview of the day.

But the thing is, I didn't make a fool out of myself. Normally—seriously—normally, I would be like, "I looooove you," and they'd be like, "Oh, thank you," and then they'd walk away. But I told her exactly how I felt and I just came right out and said it. I didn't feel like I was saying it; I couldn't hear myself, and she gave me a hug and a kiss and said, "Oh, thank you so much; that's so sweet." Then she said, "You look really familiar—I *know* you. I've *seen* you somewhere." Her publicist said, "Well, she was in *Welcome to the Dollhouse*." And she said, "No, that's not it. I've seen you somewhere." All I could say was, "I don't know, I don't know."

I did see her in a coffee shop one time when she was in *Sunset Boulevard* and it would be really freaky if she just, like, *remembered* me 'cause I said something to her *then*. But I was like nine.

Questions. Occasionally Answers

"There are no penises getting cut off. I hope that does not disappoint people."

—Gregg Araki, director of *Splendor*

After a screening of Sex: The Annabel Chong Story, *an audience member asked porn star Annabel Chong what advice she would give his girlfriend, who wanted to go into the adult-movie business.*

◊ ◊ ◊

Annabel Chong: Well, I guess my advice would be firstly to really do some soul-searching to make sure that's what she really wants to do and she should really go in there without any illusions about it and just be tough, keep her eyes open, and derive whatever she can out of it and not get caught up in a porn career, and just continue that process of soul searching.

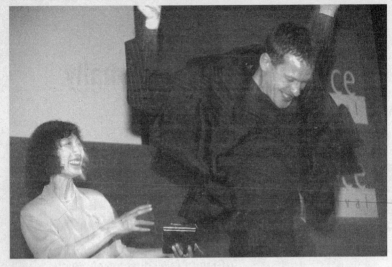

Annabel Chong and director Gough Lewis stumping for their documentary *Sex: The Annabel Chong Story.*

Audience member: What did your mother think the documentary was about before she found out it was about your porn career? [*For much of the film Chong's mother doesn't know what her student-daughter's sideline is.*]

Gough Lewis, director: When we went to Singapore she didn't know, and it was a difficult position for me, because it's not my place to tell the mother—it's just not my place. But for your own knowledge, when the mother found out about it, it was at that point that she signed the model release.

Chong: I'd like to add something to that. She thought it was about my work as a performance artist—that's

what I do at USC, study peformance art and photography and video. She did not sign the release until she found out what I did and we came to terms with it. I really appreciated Gough's sensitivity about the entire issue. 'Cause I don't want her exploited in any way. . . .

Lewis: I first saw Annabel on *The Jerry Springer Show*, so it's kind of funny that I start the film with a *Jerry Springer* clip, 'cause that was sort of my initial intro to the whole thing. But she was there to talk about fertility rites and the history of prostitutes in ancient religions. She seemed quite interesting, and the audience was like "Wow," so that's how I got involved.

Chong: It means a lot to me to be able to bring down stereotypes. That's why I decided to go ahead with this documentary.

Audience member: I found the self-mutilation scene very disturbing, and I want to ask the director, What were your feelings at that point? Did you discuss it beforehand?

Lewis: That was a pretty intense moment. I'll leave it at that.

Audience member: I would have trouble rationalizing having that moment in there. Did you have any questions for yourself or were you just able to . . . ?

Lewis: That really upset me actually. Next question?

0 0 0

Michelle LeBrun, director of the documentary *Death, a Love Story,* at the PBS luncheon: The reaction's been amazing. I mean, the Q & As have been tremendous. I realize while I'm standing at the Q & As that this is the reason I made the film. I'm going to start crying. Perfect strangers have been saying, "Thank you for making this film." A little odd thing happened yesterday: At the emotional apex of the film, a guy had a bit of a seizure. He was, like, totally fine a minute later, but it was, like, really intense. I went out and said, "You know, you better put up the lights and stop the film." People were running around screaming, "Does anybody know CPR?!" And they *didn't* stop the film; they kept it running 'cause they were tending to the guy.

And at the end of the film, you know, there are these Bulgarian voices—these strange, ethereal voices—and with all these people scurrying all over the place, I don't know what this poor guy thought when he came around! But like I said, there have been some tremendously powerful responses.

Post-Q & A

Diane Lane, star of *A Walk on the Moon,* which is set at a Jewish summer camp in the Catskills in 1969: The questions at the Q & A were smart. They were

really asking technical questions, pretty technical, and when I say technical I mean "student-ey"—and when I say students, I mean "aficionados." "What was the process of A to B to C and how do you get to D; how'd you deal with C? How was B for you? How long'd you spend writing the script, how did you know it was ready, how much did you spend on the movie?" Those kinds of questions.

There was one, somebody asked what research I had done, and basically I said, "I'm informed almost instantly when I read a script, and my gauge is the love I feel for the character." When I say "love," it's like, "Do I wanna slip into her skin? Bring this to life?" Is it, "I feel I'm the one who could really fulfill all her emotional beats and I don't want anybody else to do it? I don't want anybody else to screw this up?" That's what I mean by love.

I didn't want anything to stand in my way, like my shiksa nose or whatever I've played in the past. I always felt that they were going to get out the army of pea-shooters and say, "Well, she doesn't look Jewish," but I figure if [producer] Dustin Hoffman voted me in, you can't be any more anointed than that.

Pam Gray, the writer, was saying last night that she'd never seen a movie that deals with the borscht belt—or bungalow colonies, actually, not the borscht belt. And this movie deals efficiently with the backdrop, the ethnic thing. Before Tony [Goldwyn, the director] spent five years with her on it, before a year of prepro-duction, this script was floating around.

And she just grabbed the podium from Tony last night and said, "Tony, that's all very well to describe the five years of prep that we spent together on it, but you didn't mention the time that I was floating around as a writer with this script before you even took me on. This movie was not considered *global* enough; it was too ethnic, too 'soft.'" And that made everybody sit up and reexamine that script that's in their heart, or that they've read but are afraid won't work because a studio's not going to say, "Oh, yeah, Tom Cruise will play that and Meg Ryan will play that." And I'm not just saying big movies, but those which confidently can get made.

Liev Schreiber, Lane's co-star in *Moon*: I think they asked me, "What was it like looking at yourself?"—You know, "Is it hard for you to watch yourself?" I understand where they're coming from: your nose is six feet long projected up on a screen, and maybe it bothers you. But it's always bizarre seeing something a year, two years later. You did the work; it's not on your mind anymore. That's why it was good for me to see it last night. It was very moving.

Paola di Florio, director of *Speaking in Strings*, a portrait of Nadja Salerno-Sonnenberg, the classical violinist and inveterate chain-smoker: The oddest thing was some guy standing up and screaming and yelling and asking me why was she was smoking so much. He was outraged. *Out*raged! I don't think he got the fact that it

was a documentary, I think because it has such a dramatic structure. Most people *know* they're going to see a documentary, but I don't think that this guy *got* that it was a documentary. He thought it was some kind of drama. And he was yelling because I had allowed so much smoking. It was hilarious.

I got so desperate for financing at one point that I was literally considering writing to Philip Morris, because they own Camel [*Nadja's brand*] and saying, "This is practically a commercial for you. The most worthy thing you could put money towards is this film." But I couldn't live with myself [if I did that], so I didn't.

Gregg Araki, director, *Splendor*: Both screenings were great, the audiences were great, it was exactly what I wanted: to see the movie with a big audience. It's really exciting, and it's always the coolest thing, to see your movie for the first time with an audience, to see the reaction, where people laugh, what's not working. It's cool.

The questions were pretty similar at both screenings, 'cause this is a real departure for me; it definitely is for people who are really in tune with my body of work. It definitely makes sense; it's definitely sort of in my sensibility, the romanticism of it. I think it's in all the movies from *The Living End* on, but after finishing the "trilogy" two years ago with *Nowhere* I really wanted to do something new and different, so that's why I wanted to do this bitchy sex comedy, but I wanted to do it in this postmodern Godardian way. So the movie

for me is sort of new, millennium flavored, but at the same time has that old-fashioned kind of spirit I really wanted to go for, that thirties and forties Hollywood glamour and romance.

The Envelopes, Please . . .

*Before the fall of communism—which was about the same
time the film festival in Park City changed its name to Sun-
dance—there was a type of person known as a Kremlinologist
who could tell, just by where the politburo members stood
during the May Day tank parade, who would be the next
premier and who would soon be cutting cordwood in Siberia.*

*Park City has its own Kremlinologists, and they were
abuzz (there's that word again) at around 7:30 P.M. on Janu-*

Tony Bui's *Three Seasons*, a lyrical multiple-narrative film of contemporary Vietnam, won three awards in the Dramatic categories: the Audience Award, the Grand Jury Prize, and the Cinematography Award (Lisa Rinzler).

ary 21, 1999, when the festival's annual awards ceremony began and Robert Redford failed to take the stage. Ken Brecher, the Sundance Institute's director, made Redford's apologies and went on to restate the mission of the festival. But as fascinating as that might have been to a room half-full of flu-ridden filmmakers and journalists and half-full of corporate sponsors and local subscribers—who could now go home and tell their friends they hadn't *seen Bob in the flesh—the question was, ''Why?''*

Redford had been a no-show before—there have been festivals, in fact, when his appearances were more remarkable than his absences. But he'd made a point in recent years to make appearances at screenings during the week, be there at the end, and generally be a visible presence. So why didn't

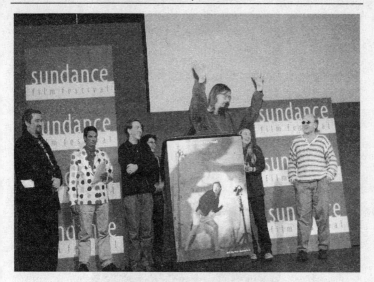

Mark Borchardt, the "star" of Chris Smith's *American Movie*, the popular portrayal of a determined Wisconsin filmmaker wanna-be.

he make it? Speculation said that he was making a state-ment—that, as he himself had admitted earlier in the week, the festival had become too commercial, and he was absenting himself to make that point.

As disappointing as this probably was to the people from Hugo Boss, Mercedes-Benz, Entertainment Weekly, *Absolut Vodka, AT&T, Kodak, Gap, Blockbuster, United Talent Agency, Piper-Heidsieck, The John D. and Catherine T. Mac-Arthur Foundation and all the other sponsors, there was a handful of people for whom* nothing *could ruin the night, at least once the awards were handed out. They included:*

- *Gavin O'Connor, who received the Filmmakers Trophy for his direction of* Tumbleweeds;

Three Seasons' Tony Bui

- *Eric Mendelsohn, who won the Dramatic jury's Directing Award for* Judy Berlin;
- *Barbara Sonnenborn, for directing the documentary* Regret to Inform, *about Vietnam War widows; and*
- *Director Chris Smith and producer Sarah Price of* American Movie, *which received the Documentary Grand Jury Prize.*

And although he had to hack and wheeze his way to the podium, director Tony Bui was the . . . well, ''star'' doesn't quite describe it. Three Seasons, *his gentle, elegant, three-pronged drama, and the first American film made in Vietnam since the war, became the only feature ever to win* both *the Dramatic Grand Jury Prize and Audience Award (as well as*

212

the Cinematography Award, which Bui accepted for Lisa Rinzler). It was a heartening thing, although Bui's multiple and less-than-economical speeches certified forever the seven scariest words at a Sundance awards ceremony:

"When I was back in film school . . ."

◑ ◑ ◑

Bingham Ray of October Films, which financed and distributed the Sundance triple-crown winner, *Three Seasons***:** It was great how I learned about the prizes. This trade reporter, who is the walking definition of the word "idiot," calls me up on my cell phone and leaves a message: "Congratulations!"—I thought it was a guy selling something—"You won both prizes! Whaddya think about that? Give me a call!"

So I called the festival press office, and they went nuts, because there was supposed to be an embargo [on that information]. Just accidentally, not to hurt him deliberately, I happened to mention, "Hey, R. J., such-and-such just left me a message that said we've won three prizes including the Audience and the Grand Jury Prize." He said "W*haaaaat!!!*" So the writer got read the riot act.

I was told by Geoff Gilmore and Nicole Guillemet that a feature had never won the Dramatic Grand Jury Prize and Dramatic Audience Award the same year. A documentary had won them both before [Barbara Kopple's *American Dream*]. So historically speaking, it's unprecedented. I can't say what it means for the film. The earlier winners of these various prizes, well, some of

them have come up short in the long history of the festival. I guess the general perception is that there's a minicurse attached to winning the Grand Jury Prize. We bought *Ruby in Paradise* during the festival in 1993 and it never performed theatrically. But *sex, lies and videotape* won the Audience prize and that performed well. *Smoke Signals* won the Audience prize last year and that did well.

Just on the surface of it, it heightens the media pedigree of the film, and that's a good thing. There's not one single negative attached to winning any prize at Sundance. Whether or not it translates into a consumer awareness and want-to-see, that's another matter. I think it depends entirely upon the films themselves, so comparing winners in years past to present, it's apples and oranges.

It's a great thing. Our friend David D'Arcy—my wife heard him on NPR this morning—he was going on and on about how *Hurricane* had done the same thing and how it took so long to release it and how "the momentum was lost." Jesus Christ. Just what we needed! And he was *wrong!*

I happened to see this film with audiences during the week and I saw it play on them—we're not talking a cross-section of America, but people who do come as nonindustry professionals, just regular Joes, interested in seeing films and skiing, and they were completely involved in what was going on. The reaction to the film and the prizes it took away exceeded all of our expectations. Out of five screenings I think there were

four standing ovations—including one late at night when everyone seemed to be drunk. Or maybe it was *me*.

I'd say we had a really good festival presentationally. We came away with another film we like very much [*Sugar Town*]. We won prizes. I'm so burned out. I saw you in the hotel Saturday and had just met with two filmmakers back-to-back, and had anyone at that point in time used the words "project" or "material" with me I would have strangled them. I could get giddy right now thinking about the insanity of that place.

So here it is awards night, and we know. Clare Ann and Melinda Hovee and I know. I pulled Jason [Kliot, the producer] aside at the beginning of the ceremony and said, "Do you want to know what I know?" He said, "What do you know?" I said, "Can you be as cool as I am? And as cool as Clare Ann and Melinda are about it? Do you *want* to know?" And of course the guy turned to butter: "Whuhwhahwhah . . ." I said, "No, you *don't* want to know what I know; go sit down and shut up."

Let me say one thing. I had a conversation with Tony [Bui, the director], with whom I'm very close. Now, this illness he had, he got the same kind of fluish symptoms the first day of shooting. He gets all worked up. So it didn't surprise me a few hours before the ceremony to be told that Tony was sick. I said, "Yeah, I could have told you." He was fine all the way through the week, partying with his ever-broadening and enlarging entourage—I looked around at one dinner, we

215

started with about four people and suddenly we had, like, forty-two people. Jesus Christ!

So Tony was sick. I said to him, "Look, if you have an opportunity to get up there and accept for something, will you take the time now, before it starts, to compose your thoughts? Think about what you want to say? Be brief, with a quality of spontaneity; a little self-deprecation never hurt. Get in and get out. Don't go up there and yammer and stammer."

He says, "No, you're right. I'll give it some thought. You think we're going to win anything?" And I said, "*If* you have the opportunity . . ."

I *knew*: he was going to have to go up three times.

So he gets up there and what does he do? He blew it! He so totally blew it, I mean *c'mon!* He could have had the media and everybody in that room, who were going home to the four corners of North America, in the palm of his hand. And he flat-out blew it. And he really, really disappointed me. When he got back to his seat the first time, he said, "How was that?" I said, "It was awful, I'm not gonna lie to you." It was all there— boom. Some people are born to get their heads blown out of shape and other people can walk the same earth no matter what the hell happens. Those coughing sounds he was making? With each one his head was getting bigger. It was like, "Oh my God, it's *Scanners!* His head's gonna *blow!*"

Postmortem

> "I thought the caliber of films available for acquisition was superior last year to this year. But I don't think that reflects negatively on the festival."
>
> —Tom Ortenberg, copresident, Lions Gate Films

> "In general, I thought the caliber of films was extremely high. Thankfully, there were very few examples of the more shopworn genres, like the Tarantino rip-offs and slacker films."
>
> —Denis O'Connor, senior vice president, Trimark Pictures

The Picture's a Little Rosier

Gavin O'Connor, who sold *Tumbleweeds* and went to Hawaii: About the festival, we were just really grateful. It's how you hope it's going to go. We felt pretty fortunate. We were just lucky, I guess.

Making a good movie is part of it, but I think there were other good movies that didn't sell, so sometimes

you think about how you got into whatever cyclical atmosphere of the market exists at a given time, and whatever these companies think about how they can distribute the film and make money on it. That's the unfortunate part.

We went in not having shown the film to anybody—we'd gotten calls; there were agents whose offices would call and say, "So-and-so wants to see your film. Send it here. . . ." We'd be like, "Why would we do that?" They just expected us to do it. But no, we didn't show it to anybody, so we came into Sundance under the radar and I think that worked in our favor. Before the festival I guess there's a certain amount of buzz about certain films and others there isn't. I don't think anyone knew anything about our film. And Janet wasn't exactly a household name.

Once we sold our film, there was a kind of change in the atmosphere, but mostly it was coming from me. I felt a little uncomfortable at times. You'd have certain filmmakers come over and offer congratulations and it was great and everything and that was nice, but I would always feel—'cause some filmmakers, I had seen their films and I really thought they were great and I also knew they hadn't sold theirs yet, for whatever reasons—so I would feel a little awkward 'cause I didn't want them to think I thought my film was any better than theirs or anything like that. 'Cause I really didn't. I was just very conscious of that.

At the awards ceremony, I was completely stunned. To be totally honest, I was hoping and thought that we

had a shot at the Audience Award, just because that's what people kept telling us the last couple of days: "You're gonna win the Audience Award." I even heard that from people who worked at the festival—not that they were counting or anything or were privy to it, but they just said, "That's what the buzz is."

So that's the one I was waiting for, hoping, thinking we had a shot at it. So when they got to the Filmmakers trophy, I wasn't really listening. I really wasn't, and then the next thing I knew, Angela and Janet had jumped on top of me. And then my dad jumped on me, too! Never in a million years did I expect that. I voted for Tony Bui!

I never talked to any of the other filmmakers about it, so I have no idea who gave us a vote, and no one ever broached the subject with me.

Sundance on the whole, it's a tough environment in some ways and, granted, we were fortunate, so the picture's a little rosier. But putting the economics aside—whether we sold or not, the whole business part of it—it was truly one of the greatest experiences of my life; it really was.

I enjoyed every moment of it, just being in that environment with all those filmmakers. I met a lot of people I thought were really cool and traded a lot of war stories and got to show my film to people and have them respond. It was just great.

We got some other offers from other companies before Fine Line bought it, but we never would have sold it to those companies, at least not then; maybe some-

where down the line I may have. But you start to panic a little bit. The festival starts on Thursday; we didn't sell ours till the next Wednesday, and we had screened it Sunday, Monday, Tuesday. You start wondering, "What's going on? Is it going to happen or not?" You start thinking about *Gods and Monsters* and *Affliction;* they never sold [at the festival], and you're like, "How can that be?" So part of that whole attitude started rearing its ugly head, that aspect of why you're there—because you're also responsible for a lot of other people's money; you want to pay people back.

Before we screened, whenever I had a chance, I would go see other people's movies. And I saw great movies, films I'd otherwise never have a chance to see, listened to the filmmakers talk about how they made them and then go have a conversation with them afterwards. The magic of that place at times— each morning you wake up and you don't know what's going to happen. Yeah, it's become a monster, it's gotten so big. I think most filmmakers wanted to be there because *everyone* wants to go there, and how do you not let it become that? Buyers show up, they want to buy movies, and you're there to sell your movie.

Afterwards, I needed a vacation, so I went to Hawaii for nine days, a little gift for myself. It was the best. Thank God I sold the film. I could never have gone to Hawaii if I hadn't sold the movie.

You Always Hope You're Catching Lightning In a Bottle

At the Time Café in New York, several weeks after the festival, Doug Block discussed the outcome of Home Page, *which was destined for a cable broadcast on HBO but was without theatrical distribution.*

It's funny how the three filmmakers I interviewed before I left Sundance had such different experiences.

DOUG BLOCK: Well, David Riker's getting picked up by Zeitgeist. I think he did pretty OK because his publicist was also my publicist and they sure spent more time with him than me. But I must say of all the films I saw there, *La Ciudad* and *Blair Witch Project* were by far the best. I was thinking about the fact that they are both very documentary influenced: *La Ciudad* just in its simplicity—it's a neorealist approach to narrative; and *Blair Witch* with documentary stock, literally documentary stock. So in the "Year of the Documentary" I liked the documentaries I saw, but none of them blew me away.

The talk was really big on how great the Documentary section was, but nothing was overwhelming.

BLOCK: You know what it is, the competition features, the fictional features, are generally weak. The really good fictional films are almost always playing around them: the World Cinema section, Midnight sec-

tion. There are some really, really great films around the periphery that people don't tend to focus on. So they say documentaries are better than the competition and they focus on *them*. It's great—I *love* that they do that! But I think that it's really knee-jerk. Everyone loves to blast the competition fictional films there.

Well, some of them were truly bad. You probably didn't get to see many.

BLOCK: You know why it is? If they are really good, they've already been picked up by a distributor. If they've been out at all, they've been to Toronto—a lot of them come in from there. There's so much attention paid—these distributors scour the world. They know about everything in progress, and if they are very aggressive they've locked some of these better ones up. The ones in the competition generally have just been finished. How many good films come out of here? With the documentaries, there is a much broader range of good, really solid, well-done documentaries. If you had to come up with fifty really good documentaries in a year, you probably could. Not all of them great, but your fiftieth documentary would still be pretty solid. Your fiftieth fictional film—American indie, low-budget fictional film—is going to be dreadful. Your twenty-fifth is going to be dreadful. Coming up with *sixteen*, you are going to have some dreadful ones! They look at hundreds and hundreds of them. It really tells you just how hard it is to make a really great fictional film.

But it's not hard to make a really good documentary?

BLOCK: No, it's *really hard*. But documentaries also incorporate, I think, stylistically a greater range. You've got your solid PBS-style ones which are interview-intensive, maybe narrated, well researched, historical. But you've also got much more innovative stuff being done in terms of storytelling. I think documentaries are much more focused on storytelling these days, in the kind of sweeping narrative sense, less [voice-over], more character driven. I don't know how else to put it—story driven. And they can be filmed over a much longer period of time. Look at *Hoop Dreams*—filmed over four years, so you really get a sense of the changes [in people's lives]. I shot *Home Page* only over nine months basically, but the Web changed so fast that those nine months might as well have been nine years. You really get a sense of changes going on in this world that Justin and Howard Reingold are a part of. I also caught a transformational year—I was lucky that way.

It's funny how spoiled you get. Did you see On the Ropes *[a boxing documentary captured behind the scenes of a Brooklyn gym]?*

BLOCK: I saw it actually as a fine cut. I know they did some more editing, but I didn't see it at Sundance.

I like it. But I kind of wanted it to be done over a longer period of time. I wanted more.

BLOCK: There's an irony behind why documentaries have a certain richness. If you're filming over three or

four years, it's usually because you're trying to raise the money. *The Heck with Hollywood!* covered a three-year period because I spent three years trying to get the money for it, and the last year I was finishing it up, so I was still filming. Things were still happening with the subjects, so you really get a sense of their lives changing over time. It's not always that people *want* to do it that way. I think they (*On the Ropes*) were able to get the funding so they didn't have to keep shooting forever.

Did you get approached by anyone about buying your film? What was the business end of it like for you?

BLOCK: It was frustrating. I had a big obstacle—the HBO signature broadcast. And there was no way to disguise it. Nor was I inclined to disguise it. They were my primary funder. I can't *ignore* them. So it was a tricky matter to try to deemphasize their involvement.

How does that make them feel?

BLOCK: Well, I'm sure it doesn't make them feel *good*. They got very excited about my being at Sundance. They wanted to make a poster. I saw the poster and there in big letters: "It's not TV. It's HBO." I can't have that out at Sundance. I'm trying to entice a theatrical distributor. It's not like I'm going to lie to them and not tell them about the broadcast that has to happen before it gets out theatrically. It's only a six-week window on HBO and six showings. But I figured at least let's try to get distributors into the film. If they are really interested then it's not a problem for them.

The distributors all knew at Sundance that they had HBO, and yet HBO was still approached by a number of big distributors. They just didn't like what they were offered—that's all. But they told me that they had all sorts of distribution deals on the table. I wanted to at least get the distributors in. I figured that if the name HBO was too attached to it, then I wasn't going to even get them in the door. As it was I still didn't get them in the door because—well . . . for one I had a screening at the Independent Feature Film Market in September and we had a lot of representatives from a lot of distributors there. And it could have been a mistake. The films that do really well at Sundance invariably tend to be seen for the first time there. It's a big strategic move to not let anyone see it until your Sundance premiere. It's a smart strategy. On the other hand you'd better have a damn good film! What happened with me and the IFFM, I just had to support what they do as an organization. The stakes aren't quite as high; I mean, I'm a documentary filmmaker, I had the broadcast [rights sewn up], I could have waited until Sundance. But I used the IFFM as a springboard for getting [into other] festivals. For instance, the Berlin people are there. We'd gotten into Rotterdam. We wanted to get a quick answer from Berlin. You show it there, they can tell you in five seconds whether they want it or not. I'd rather Sundance see the film *on film* with an audience than to get it on tape. In fact, one of their programmers came to the IFFM, really liked it. She told me months later when it was already in that she pretty much knew at

the time that it was going to be in. Instead, I had to go through months of torture waiting for the answer when they pretty much knew. But then again it was at those screenings at the IFFM that my editor and I realized that the film was still too long. So we were still using the screening, still seeing the film as a work-in-progress even though it was finished. In some ways, it's never finished. The film was fifteen minutes shorter at Sundance and better by a long shot.

Hadn't Sundance programmers said to you that they thought it was long?

BLOCK: Yes, they did. But they liked it. We knew at the IFFM that we wanted to shorten it, and we still had a month and a half to hear back from them [Sundance]. It was agonizing: do we tell Sundance we want to shorten it or not? And I just decided not to. I thought it would be a mistake. It would be like apologizing for your film. And then they would be guessing *which* fifteen minutes. It puts them in a very funny position. And I do trust their selection process. A lot of filmmakers gripe, particularly once they get left out. I'm sure they are overwhelmed. And I do have an advantage because they know who I am. They knew my film. It was unlikely they were going to turn *Home Page* off after five minutes.

Which they do with some films and then return them unrewound.

BLOCK: Do they really? That's cruel. But not as cruel as Slamdance, which sent out their rejection notice by

mass e-mail that had *everyone's* name in the header. They must have had fifty names in the header because they didn't know how to do a blind cc. It was like this mass form—it was like this very, very tacky thing. And they were trying to be so nice but they went so overboard. It was actually sort of nauseating.

All of this is to say—if there were any distributors in my screenings, I didn't see them. We got approached by two distributors after the IFFM. You always hope you're catching lightning in a bottle. That's basically what you're going out to Sundance for. You try to keep your expectations low—particularly if you're a documentary filmmaker. But then you get out there and you're in this environment that plays mind games on you. You just can't be unaffected by what's going on—the heat and the tension on other films. I go into Holiday Village and I see the lines for *American Movie* or *American Pimp* or *Sex: The Annabel Chong Story*. And I say, "Oh, man. How come I don't have lines like that? How can I get lines like that?" Because if you're not getting distributor interest, the first thought is that we have to build distributor interest. What can you do? One thing you can do is try to get audiences in. If they're turning away crowds, that's something. So for a couple of days I just drove myself crazy. I took my postcards and I went down lines for other documentaries and talked up the film. It actually turned out to be one of the best experiences I ever had there because I met a lot of people. I had great talks with people on line. And towards the end of the festival every other

person on line had heard about *Home Page*. And some people had seen it. It really was a wonderful way of getting feedback and word of mouth. We weren't one of the hot films there, but it became clear that we were really well respected and liked, and that people were *talking* about us. So that was really gratifying. It didn't stop me from being frustrated to no end that we couldn't build a bigger buzz around it. Virtually every screening was full. But the business part was hard.

So where do you stand now?

BLOCK: The one theatrical distributor who was interested and is still interested I scared off.

Good work!

BLOCK: Because I've had a lot of time to think through what I want out of this. And I've come to the conclusion that the theatrical experience is very overrated—particularly when you have a sixteen-millimeter film on your hands. Sixteen millimeter is on its deathbed and I want to be its Kevorkian. It's a nightmare. In two or three years it's going to be gone. Here it is, Sundance, the premier festival of the country. I have four screenings at the Holiday Village I, where the sound was unspeakably dreadful. For the first two screenings they didn't even open the curtain wide enough to keep from cutting off part of the screen. The bulb was two stops too dark. They wound up putting another bulb in after the second screening, so that was somewhere in the ballpark of where it should have

been. But still not quite bright enough. They had terrible focusing problems. The biggest problem was that the sound got muddy and brought the background sound up. It's not just Sundance's fault; I've seen it in different theaters. The Holiday screening was dreadful; the Prospector screening was perfect. I was talking with Michel Negroponte, who was a juror and had seen the film before; he said, "You were really harmed by that theater, 'cause I know the subtleties of what you were trying to do and it got lost."

But digital is going to turn the industry around. George Lucas is projecting *Star Wars* on digital in some theaters, and I hear Sundance is going to have a section on video. The IFFM, which always insisted that you have your film on film, is now going to play video. It's good for filmmakers like me—for any indie makers, but documentary makers particularly—because if you think you have any chance of getting theatrical release and spend ten, twenty, thirty thousand dollars on a sixteen-millimeter print—which isn't really release-worthy—it's money spent just on the *hopes* you'll get a release. Wrong model. For one thing, if you find like I did that you think your film's too long you can cut it down for fifteen hundred dollars on digital. But we then had to make another tape-to-film transfer for ten thousand dollars only because we *had* to be on film. I can say I should have known the film was long beforehand, but before you play it with audiences it's hard to tell; it took three or four industry people to tell me before I accepted it, before it became clear to me.

But it's really exciting when you think what it can do for the future of filmmaking. If you amortize the amount of showings I've had, and the cost to get it to sixteen millimeter, it's probably a thousand dollars a screening. It may be under that by the end, but as the costs come down you're also going to wind up having a lot of great unusual films coming out. My hope is for a lot of daring political films: you can make it, not have to spend thousands on the blowup, and be more daring. There's going to be a lot of dreck, too. But there is now! And that's a problem for the jury members, not me.

Sundance? It was the best of times and the worst of times—90 percent was the best of times. It was exciting, frantic; you'll never get as much attention. We had almost constant interviews, Q & As, screenings, parties, drink fests. I hardly had time to make calls, no time to eat. No time to sleep. I didn't do a lot of big parties. My idea of a good time is a few people and a few drinks; I don't want to go to these blowouts and meet a lot of people from L.A. And they certainly don't want to meet me!

Following the broadcast of Home Page *on HBO in the summer, Block took the innovative route of selling tapes of the film directly, on-line, from his Web site, www.d-word.com, maintaining links to the Web personalities whose lives are documented in the film. It is, as Block explained, the first "truly interactive movie" in that audiences could enter into dialogues with the film's subjects and thus expand the scope of the film experience itself.*

At Its Core There Is a Strong, Strong Identity

In April, David Riker spoke from the Taos Talking Picture Festival, where he was showing La Ciudad.

Your story is rather remarkable because you blew off the chance to be in the Sundance competition in order to play the other festival in Los Angeles first.

RIKER: And to this day there are those who think it was a mistake.

We've done a slew of festivals since—we did Taos, Santa Barbara, San Diego, and South by Southwest [in Austin], and then the Human Rights Watch Festival in June. Then the film, if all goes well, should open in the fall.

I'm coming to the end of this long, many months of traveling with the film. I started work on a new project right after Sundance. So all my energies are going towards something new.

But I am out here at the Taos festival showing the film. There are four films that are what they call land-grant finalists, and the winner gets five acres of prime Taos land. I just had a couple of interviews with the Independent Film Channel about how I plan to develop the land. To me the idea of owning land is the *farthest* thing from my mind.

Where is this land?

RIKER: About fifteen minutes west of downtown Taos on the Taos mesa.

So it's not like it's underwater or anything?

RIKER: No, but I think it's very near to the Rio Grande. The last winner was Chris Eyre from *Smoke Signals*.

Are all these parcels of land next to each other so you can create a little film community?

RIKER: Yes. They're all contiguous.

Who are the finalists?

RIKER: Most of them were at Sundance. *On the Ropes*, *The Source*, a documentary about Allen Ginsberg and the Beats by Chuck Workman, and a thriller called *Oxygen*. It's a unique initiative, but it's a complicated scenario about [whether it should be] private or communal. Theoretically every director would own their own piece of land, but underneath is this view that they want to create some sort of long-term artistic community.

It's better than a plaque from Sundance, I guess.

RIKER: Oh, yes. It's better than a plaque from Sundance.[1]

So back to Sundance: what's your lingering impression?

RIKER: I hadn't really thought about it much until your call.

[1] *La Ciudad* won the Taos Talking Picture Festival's Land Grant Award, and Riker indeed was a recipient of five acres of land.

The last time we talked at length at the festival you seemed a little unhappy with the interest in the film.

RIKER: We had waited a long time to see if Sundance was going to deliver us from our situation, and it really had no effect at all. In hindsight, I'm not sure if we made a bad decision and lost time by going. But the original companies that offered to distribute the film virtually the morning after they saw it at the Toronto Film Festival were the same companies that we had to deal with six months later.

What were the companies?

RIKER: Zeitgeist, Kino International, and this guy named Marc Smolowitz from Turbulent Arts. He's a new character out of San Francisco. Kino and Zeitgeist made it very clear the night they saw it or the next morning that they were interested.

And you went with one of them?

RIKER: Zeitgeist. They're good people. They are very, very shrewd and hard. So when they are working for the film, I think it's going to be great.

So are you saying that Sundance didn't do much for you at all?

RIKER: In terms of *La Ciudad*, it didn't do anything. The festival was exhausting. I was there for ten days. It's a very difficult place for a filmmaker. I didn't find it filmmaker-friendly. I found it to be one of the most unfriendly environments. It was hard to find places or

time to talk to other filmmakers. Everyone who is there—every filmmaker—is hoping that their life will be changed, and instead of looking at the work that we've all produced, everyone is running around trying to see if their film is going to win. I was doing the same thing. I was doing interviews every day, always being on standby. It's indisputable that having *La Ciudad* at Sundance is important in another sense. It's considered by a lot of people as a sign that your work is good— regardless of whether distributors pick it up. And I'm in discussions regarding a number of projects that are the direct result of Sundance—either because people who hadn't seen *La Ciudad* yet saw it there or because I met them there. I'm sure that they are influenced by the fact that they are seeing someone's work at Sundance. I had a fairly bad attitude going there, about what Sundance is. And when I was there on a day-to-day basis it didn't get any better. I saw the wealth. It's some kind of a playground for the industry. On the other side, I saw the filmmakers spending their own money to stay there or to cover the cost of getting there in addition to what Sundance provides. Filmmakers were struggling.

Then, sometime toward the middle or towards the end of the festival, I was in the hospitality suite and I heard that Sundance's technical director, Ron Montgomery, had died the night before from a heart attack. Remember that? I couldn't believe it, because it appeared the festival was just going ahead without any notice of his death. I started to rant—you know, how

this was just another sign of how empty and cold the festival was. And someone sitting at a table nearby came over and told me that there was a memorial for him.

So I went to that memorial. I got to the mall and got some flowers and my DP and I went over not knowing who this guy was but hearing that this guy had really fought for the best projection facilities, to improve the facilities and get more money for the sound equipment. The memorial was extremely power-ful—filled with all the Sundance characters that you hear about long before you get there: the programmers, the executive director, the people I've met in print traf-fic, the volunteers that had been selling T-shirts or showing you to the buses. Almost as soon as I got there a young woman stood up and sang this rendition of "Amazing Grace"—it had like this Appalachian energy to it. Then one after another people stood up and talked about their friendship with this technical director and their loss. It changed my attitude completely about the festival. It made me think that the reason that the festi-val is as important as it is, is because at its core there is a strong, strong identity that is carried by the handful of people who have been there for a while. I left there saying to myself that I wouldn't bad-mouth the festival again. What I saw there was a real, genuine sense of *community*.

Today I had lunch with a guy named Jeff who was one of the people in charge of print traffic at Sun-dance—he had to receive and ship out all the prints. I

had met him when I brought my print in, the way every filmmaker does. I said hi to him, told him to take care of the print, and never thought I'd see him again. When I entered the memorial he came over and gave me a hug. The other day I bumped into him on the street in Taos and we had lunch together. I felt a really strong connection to the man. He also said that very few filmmakers even made it to the memorial, but then again, most people didn't know [about it].

I thought it was weird that Redford didn't come to the awards ceremony. Did you go?

RIKER: I went to the awards thing. It's best not to go to an award ceremony if you are not going to get an award. But Redford is kind of like a phantom. He has a phantomlike presence around that festival. I think I saw him three or four times in various places. At one moment I got a chance to talk to him, and my overwhelming feeling is that he is a reluctant, reluctant public figure. He doesn't really want to be standing in the limelight for Sundance. I was told by one of the people involved in the origins of Sundance, Jeff Dowd, that the idea behind Sundance was like bringing the mountain to Mohammed. Redford's personality wasn't going to be conducive to being in Los Angeles. He wanted to be deep in the woods, but he also wanted to have impact. They wanted to bring the film experience to him. But he's extremely reluctant—I don't think he wants the job he has got. I talked to him at his restaurant, about working with nonactors and actors together. I

thought I was talking to him as if I were talking to an actor, but he made it clear that he wanted to talk to me as a director. I have nothing significant to say about my encounter with Robert Redford. It's probably going to be obvious in your book that Sundance is deeply— whether they like it or not—a market, and it's not clear how they can easily change that fact or if they *want* to change it. That's where their power comes from.

THE LINEUP

The following is a list of feature films screened at the 1999 Sundance Film Festival. As of this writing (in the Summer of 1999), roughly half have received U.S. distribution deals.

DRAMATIC COMPETITION

The Adventures of Sebastian Cole
Directed by Tod Williams
Distributor: Paramount Classics

The Autumn Heart
Directed by Steve Maler

Getting to Know You
Directed by Lisanne Skyler

Guinevere
Directed by Audrey Wells
Shared the Waldo Salt

Screenwriting Award with *Joe the King*. Distributor: Miramax

Happy, Texas
Directed by Mark Illsley
Winner, Special Jury Award, for Comedic Performance (Steve Zahn). Distributor: Miramax

The Hi-Line
Directed by Ronald Judkins

Edie Falco and Aaron Harnick in
Judy Berlin

The Item
Directed by Dan Clark

Joe the King
Directed by Frank Whaley
Shared the Waldo Salt
Screenwriting Award with
Guinevere. Distributor: Trimark
Pictures

Judy Berlin
Directed by Eric Mendelsohn
Winner, Directing Award,
Dramatic Category. Distributor:
The Shooting Gallery

The Minus Man
Directed by Hampton Fancher
Distributor: Artisan
Entertainment

Roberta
Directed by Eric Mandelbaum

A Slipping-Down Life
Directed by Toni Kalem

Three Seasons
Directed by Tony Buì
Winner of the Audience Award
and the Grand Jury Prize. Lisa
Rinzler also received the
Cinematography Award.
Distributor: October Films.

Treasure Island
Directed by Scott King
Winner, Special Jury Award,
"for distinctive vision in
filmmaking."

Trick
Directed by Jim Fall
Distributor: Fine Line Features

Tumbleweeds
Directed by Gavin O'Connor
Winner, Filmmakers Trophy.
Distributor: Fine Line Features

DOCUMENTARY

American Hollow
Directed by Rory Kennedy
Distributor: HBO

American Movie
Directed by Chris Smith
Winer of Best Documentary,
Distributor: Sony Pictures
Classics.

American Pimp
Directed by Albert and Allen
Hughes. Distributor: Seventh
Art

*The Black Press: Soldiers Without
Words*
Directed by Stanley Nelson
Winner, Freedom of Expression
Award. Broadcast: PBS

Death: A Love Story
Directed by Michelle LeBrun

*Hitchcock, Selznick and the End of
Hollywood*
Directed by Michael Epstein
Broadcast: PBS/*American Masters*

Nadja Salerno-Sonnenberg in
Speaking in Strings

Home Page
Directed by Doug Block
Broadcast: HBO

*The Legacy: Murder & Media,
Politics & Prisons*
Directed by Michael J. Moore
Broadcast: PBS/*P.O.V.*

The Living Museum
Directed by Jessica Yu

On the Ropes
Directed by Nanette Burnstein
and Brett Morgen
Winner, Special Jury Award.
Distributor: WinStar Cinema

Rabbit in the Moon
Directed by Emiko Omori

Cowinner (with *Regret to Inform*) of the Cinematography Award.
Broadcast: PBS/*P.O.V.*

Regret to Inform
Directed by Barbara Sonnenborn
Won the Directing Award; shared the Cinematography Award with *Rabbit in the Moon*.
Broadcast: PBS/*P.O.V.*

Sex: The Annabel Chong Story
Directed by Gough Lewis

Sing Faster: The Stagehands' Ring Cycle
Directed by Jon Else
Winner, Filmmakers Trophy.

The Source
Directed by Chuck Workman
Distributor: WinStar Cinema

Speaking in Strings
Directed by Paola di Florio
Distributor: Myriad Pictures

WORLD CINEMA

The Adopted Son (Beshkempir) (Kyrgystan/France)
Directed by Ahtab Abdykalykov

After Life (Japan)
Directed by Kore-Eda Hirokazu
Distributor: Artistic License

Bajo California: El Limite Del Tiempo (Under California: The Limits of Time) (Mexico)
Directed by Carlos Bolado

Barrio (Spain)
Directed by Fernando Leon de Aranoa

Beefcake (Canada)
Directed by Thom Fitzgerald

Black Cat, White Cat (Yugoslavia)
Directed by Emir Kusturica
Distributor: October Films

Dance of Dust (Iran)
Directed by Abofazl Jalili

Forever Fever (Singapore)
Directed by Glen Goei
Distributor: Miramax

Friendly Fire (Brazil)
Directed by Beto Brant

Get Real (Great Britain)
Directed by Simon Shore
Distributor: Paramount Classics

Heart of Light (Greenland)
Directed by Jacob Grenlykke
Distributor: Phaedra Films

The haunting *After Life*

I Stand Alone (Seul Contre Tous)
(France)
Directed by Gaspar Noe
Distributor: Strand Releasing

Life Is to Whistle (La Vida Es Silbar) (Cuba)
Directed by Fernando Perez
Winner, Special Jury Award,
Latin American Cinema.

Life on Earth (La Vie Sur Terre)
(France/Mauritania)
Directed by Abderrahmane Sissako

Little Thieves, Big Thieves
(Venezuela)
Directed by Alejandro Saderman

Louise (Take 2) (France)
Directed by Siegfried

The Lovers of the Arctic Circle
(Spain)
Directed by Julio Medem
Distributor: Fine Line Features

From Germany: Tom Tykwer's kinetic *Run Lola Run*, winner of the Audience Award.

Megacities (Austria)
Directed by Michael Glawogger

P. Tinto's Miracle (El Milagro de P. Tinto) (Spain)
Directed by Javier Fesser

Praise (Australia)
Directed by John Curran

Run Lola Run (Germany)
Directed by Tom Tykwer
Winner, Audience Award (the first time given in World Cinema). Distributor: Sony Pictures Classics

Silvia Prieto (Argentina)
Directed by Martin Rejtman

Southpaw (Ireland)
Directed by Liam McGrath

The Terrorist (India)
Directed by Santosh Sivan

Train of Life (Train de Vie) (France/Belgium/Netherlands)
Directed by Radu Milhaileanu
Winner, Audience Award (the first given in World Cinema). Distributor: Paramount Classics

2 Seconds (2 Secondes) (Canada)
Directed by Manon Briand

Under a Spell (Un Embrujo)
(Mexico)
Directed by Carlos Carrera

When Love Comes (New Zealand)
Directed by Garth Maxwell
Distributor: Jour de Fete Films

The Wounds (Yugoslavia/France)
Directed by Srdjan Dragojevic

AMERICAN SPECTRUM

Afraid of Everything
Directed by David Barker

Chillicothe
Directed by Todd Edwards

The Corndog Man
Directed by Andrew Shea

Drylongso (Ordinary)
Directed by Cauleen Smith

Edge of Seventeen
Directed by David Moreton
Distributor: Strand Releasing

Fools Gold
Directed by Jeffrey Janger

Genghis Blues
Directed by Roko Belic
Distributor: Roxie Releasing

The Invisibles
Directed by Noah Stern

La Ciudad (The City)
Directed by David Riker
Distributor: Zeitgeist

Langmuir's World
Directed by Roger R.
Summerhayes

Life Tastes Good
Directed by Philip Kan Gotanda

The Outfitters
Directed by Reverge Anselmo

Possums
Directed by J. Max Burnett

Radiation
Directed by Suki Stetson
Hawley and Michael Galinsky

Return with Honor
Directed by Freida Lee Mock
and Terry Sanders
Distributor: Ocean Releasing

Side Streets
Directed by Tony Gerber

Twin Falls, Idaho
Directed by Michael Polish
Distributor: Sony Pictures
Classics

Valerie Flake
Directed by John Putch

FRONTIER

Brakhage
Directed by Jim Shedden
Distributor: Zeitgeist

dresden
Directed by Ben Speth

Speedy Boys
Directed by James Herbert

Trans
Directed by Julian Goldberger

Yusho-Renaissance
Directed by Hiroyuki Oki

NATIVE VISION

Allan Houser-Haozous
Directed by Phil Lucas

Big Bear
Directed by Gil Cardinal
Broadcast: CBC

City of Dreams
Directed by Jorge Manzano

The Gift
Directed by Gary Farmer

Hidden Medicine
Directed by Robby Romero

The Honour of All
Directed by Phil Lucas

Silence
Directed by Jack Darcus

Singing Our Stories
Directed by Annie Frazier
Henry

Storyteller
Directed by Richard Dargan

Things We Do
Directed by Chris Eyre

Today Is a Good Day:
Remembering Chief Dan George
Directed by Loretta Todd

Way of the Glades
Directed by John McCuen

PREMIERES

Cookie's Fortune
Directed by Robert Altman
Distributor: October Films

Go
Directed by Doug Liman
Distributor: Columbia Pictures

Hideous Kinky
Directed by Gillies MacKinnon
Distributor: Stratosphere
Entertainment

Jawbreaker
Directed by Darren Stein
Distributor: Tri-Star Pictures

Lock, Stock and Two Smoking Barrels
Directed by Guy Ritchie
Distributor: Gramercy Pictures

The Loss of Sexual Innocence
Directed by Mike Figgis
Distributor: Sony Pictures
Classics

Mr. Death: The Rise and Fall of
Fred A. Leuchter, Jr.
Directed by Errol Morris
Distributor: Lions Gate

The Passion of Ayn Rand
Directed by Christopher
Menaul
Broadcast: Showtime

Santitos
Directed by Alejandro
Springall

SLC Punk!
Directed by James Merendino
Distributor: Sony Pictures
Classics

Splendor
Directed by Gregg Araki
Distributor: Samuel Goldwyn Co.

Holocaust-denier Fred Leuchter, as photographed in the Boston Science Museum's Theater of Electricity, in Errol Morris' documentary *Mr. Death.*

Sugar Town
Directed by Allison Anders and Kurt Voss
Distributor: USA Films

Thick as Thieves
Directed by Scott Sanders
Distributor: Rogue Pictures

The 24-Hour Woman
Directed by Nancy Savoca
Distributor: The Shooting Gallery

Two Hands
Directed by Gregor Jordan

A Walk on the Moon
Directed by Tony Goldwyn
Distributor: Miramax

The War Zone
Directed by Tim Roth
Distributor: Lot 47

MIDNIGHT
The Blair Witch Project
Directed by Eduardo Sanchez and Daniel Myrick

Distributor: Artisan
Entertainment

Get Bruce
Directed by Andrew J. Kuehn
Distributor: Miramax

Kill the Man
Directed by Tom Booker and
Jon Kean
Distributor: Rogue Pictures

Los Enchiladas!
Directed by Mitch Hedberg

Mighty Peking Man
Directed by Ho Meng-Hua
Distributor: Cowboy Booking

Samurai Fiction
Directed by Hiroyuki Nakano
Distributor: Pony Canyon

Serial Lover
Directed by James Huth

SPECIAL SCREENINGS

An American Love Story
Directed by Jennifer Fox
Broadcast: PBS

A Hard Day's Night
Directed by Richard Lester
Distributor: Miramax

El Norte
Directed by Gregory Nava
Distributor: Artisan
Entertainment

The Kindness of Strangers
Directed by Maro Chermayeff

The Awards

Documentary Competition

Grand Jury Prize: *American Movie*
Directing Award: Barbara Sonnenborn for *Regret to Inform*
Freedom of Expression Award: *The Black Press: Soldiers Without Swords*
Audience Award: *Genghis Blues*

Cinematography Award: Emiko Omori for both *Rabbit in the Moon* and *Regret to Inform*

Filmmakers Trophy: *Sing Faster: The Stagehands Ring Cycle*

Special Jury Award: *On the Ropes*

Dramatic Competition

Grand Jury Prize: *Three Seasons*

Directing Award: Eric Mendelsohn for *Judy Berlin*

Waldo Salt Screenwriting Award: Audrey Wells for *Guinevere* and Frank Whaley for *Joe the King*

Audience Award: *Three Seasons*

Cinematography Award: Lisa Rinzler for *Three Seasons*

Filmmakers Trophy: *Tumbleweeds*

Special Jury Award for Comedic Performance: Steve Zahn for *Happy, Texas*

Special Jury Award for Distinctive Vision in Filmmaking: *Treasure Island*

Short Filmmaking

Jury Prize in Short Filmmaking: *More*

Special Jury Award in Short Filmmaking: *Fishbelly White*

Honorable Mention in Short Filmmaking: *Atomic Tabasco; Come Unto Me: The Faces of Tyree Guyton; Devil Doll/Ring Pull; A Pack of Gifts; Now Stubble Trouble*

Latin American Cinema

Jury Prize in Latin-American Cinema: *Santitos*

Special Jury Award in Latin-American Cinema: *Life Is to Whistle (La Vida Es Silbar)*

World Cinema

Audience Award for World Cinema: *Run Lola Run* and *Train of Life (Trian de Vie)*

APPENDIX

Sources

Author interviews with filmmakers and festival participants were conducted during fall and winter 1998–1999. In addition, quotes were reprinted from the following sources:

p. 29, Urman: "A lot of films are just too fragile . . ." Caro, Mark, "For a Dramatic Showcase, This Fest Lacked Real Passion," *The Chicago Tribune*, February 7, 1999.

p. 62, Riker: "The basic outline for the stories occurred . . ." Garrett, Stephen, "No Man's Land," *Filmmaker Magazine*, February–April 1999.

p. 93, Anonymous: "That's Altman, you idiots!" Vice, Jeff, "The Good, the Bad and the Ugly at '99 Sundance Festival," *Deseret News* [Salt Lake City], January 31, 1999.

p. 96, Altman: "We got offers from Cannes . . ." Vice, Jeff, "Filmmaker Downplays Works, Says He Just Aims for Truth," *Deseret News* [Salt Lake City], January 24, 1999.

p. 99, Sevigny: "You create this early buzz . . ." Forrest, Emma, "Courting the New Sun Kings," *The Guardian*, January 31, 1999.

p. 99, Sheedy: "What's the last year been like . . ." Fleeman, Michael, "Sundance Festival Brings in Big Bucks for Some Unknown Films," *Associated Press*, January 21, 1999.

p. 105, Kaffey: "They are in deep trouble. . . ." Van Eyck, Zack, "As Festivals End, Park City Cleanup Kicks In," *Deseret News* [Salt Lake City], January 31, 1999.

p. 133, "At 4:44 P.M. . . ." "Police Blotter," *The Park Record*, January 27, 1999.

p. 136, Farnsworth: "Towing a car is our last resort . . ." Van Eyck, Zack, *Deseret News* [Salt Lake City], January 28, 1999.

p. 137, Bennion, "We impounded Clint Eastwood's car . . .", *Ibid*.

p. 149, Rosen: "Every buyer here is panicked at this point. . . ." Hardy, Ernest, "The Talk of Sundance," *L.A. Weekly*, February 5–11, 1999.

p. 149, Paget: "I am 32 now. . . ." Curtis, Larry, "Filmmaker's New Adventure: Wooing Viewers," *Deseret News* [Salt Lake City], January 29, 1999.

p. 177, Moore: "Sometimes, it opens doors." Bleyle, Kirsta H., "Three Strikes and You're Out," *The Park Record*, January 20, 1999.

p. 179, Gruben: "We went back and forth . . ." Hardy, Ernest, "The Talk of Sundance," *L.A. Weekly*, February 5–11, 1999.

p. 198, ". . . When it received a standing ovation from the surviving audience members." "Straight Outta Sundance," msn online, January 27, 1999.

p. 198, Loeb: "It's all right . . ." Howell, Stephanie, "Elk's

Lodge Comes Alive with Sounds of Lyle, Moore, Loeb and Sheik," *The Park Record*, January 27, 1999.

p. 198, Sheik: "They're incredibly vague. . . ." *Ibid.*

p. 217, Ortenberg: "I thought the caliber of films available . . ." Hindes, Andrew, and Petrikin, Chris, "Plenty of Sales but Few Breakouts at Sundance," *Variety*, January 31, 1999.

p. 217, O'Connor: "In general, I thought the caliber of films was extremely high. . . ." *Ibid.*

Photo Credits

Original photographs © 1999 by Randall Michelson.

Film Stills

p. 8, *sex, lies and videotape*: courtesy of Outlaw Productions, © 1989.

p. 8, *Hoop Dreams:* courtesy of Kartemquin Educational Films, 1991. Photo by Alma Komodin.

p. 8, *Welcome to the Dollhouse:* courtesy of Todd Solondz. © 1996 Sony Pictures Classics. Photo by Jennifer Carchman.

p. 8, *The Opposite of Sex:* courtesy of Columbia Tristar Home Video, Inc.

p. 19, *Stranger Than Paradise:* courtesy of MGM Consumer Products, a division of MGM Home Entertainment, Inc. Copyright © 1984 The Samuel Goldwyn Company. All Rights Reserved.

p. 51, *Tumbleweeds*: copyright © 1999, New Line Productions, Inc. All rights reserved. Photo by Michelle Carmichael. Photo appears courtesy of New Line Productions.

Index

ABOUT THE AUTHOR

John Anderson is the chief film critic for *Newsday*. He has contributed to the *Los Angeles Times*, the *Washington Post*, *Film Comment*, *Billboard* and *The Nation*, and has taught at the Eugene O'Neill Theatre Center. He is a member and past chairman of the New York Film Critics Circle, a member of the National Society of Film Critics and of FIPRESCI, the international critics' organization. He has survived nine Sundance Film Festivals, and has also served as a juror at several international film festivals held in more tropical climes. He lives in New York City.